D0923029

ART FROM ABOVE

VERMONT

+ CALEB KENNA +

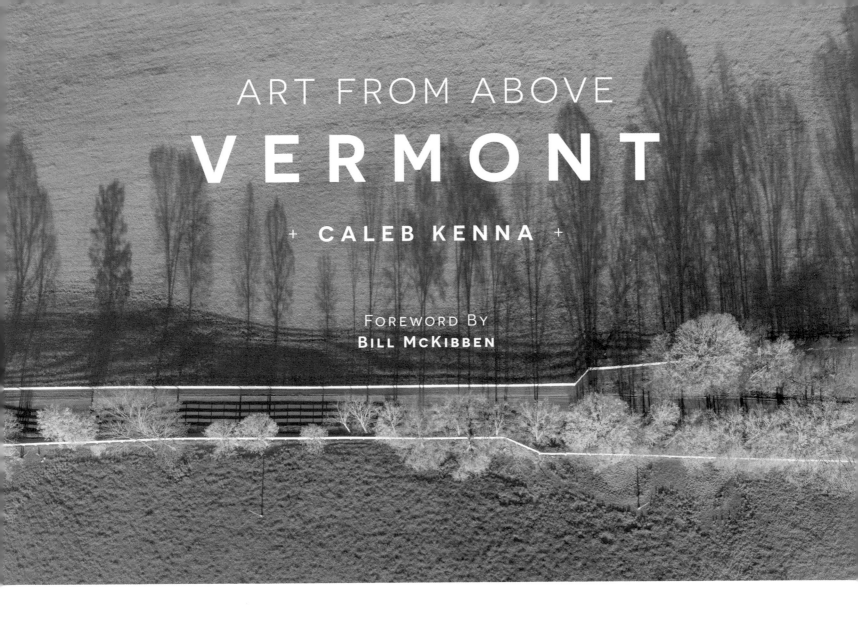

ART FROM ABOVE
VERMONT

+ CALEB KENNA +

FOREWORD BY
BILL MCKIBBEN

SCHIFFER
PUBLISHING

4880 Lower Valley Road · Atglen, PA 19310

OTHER SCHIFFER BOOKS ON RELATED SUBJECTS:

Art from Above: Cape Cod, Christopher S. Gibbs, ISBN 978-0-7643-5747-3

Vermont: An Autumn Perspective, Ken Paulsen, ISBN 978-0-7643-5390-1

Copyright © 2022 by Caleb Kenna

Library of Congress Control Number: 2022931674

All rights reserved. No part of this work may be reproduced or used in any form or by any means—graphic, electronic, or mechanical, including photocopying or information storage and retrieval systems—without written permission from the publisher.

The scanning, uploading, and distribution of this book or any part thereof via the Internet or any other means without the permission of the publisher is illegal and punishable by law. Please purchase only authorized editions and do not participate in or encourage the electronic piracy of copyrighted materials.

"Schiffer," "Schiffer Publishing, Ltd.," and the pen and inkwell logo are registered trademarks of Schiffer Publishing, Ltd.

Edited by Cheryl Weber
Designed by Christopher Bower
Cover design by Christopher Bower

Type set in Novecento sans wide /Minion Pro

ISBN: 978-0-7643-6437-2
Printed in India

Published by Schiffer Publishing, Ltd.
4880 Lower Valley Road
Atglen, PA 19310
Phone: (610) 593-1777; Fax: (610) 593-2002
Email: Info@schifferbooks.com
Web: www.schifferbooks.com

For our complete selection of fine books on this and related subjects, please visit our website at www.schifferbooks.com. You may also write for a free catalog.

Schiffer Publishing's titles are available at special discounts for bulk purchases for sales promotions or premiums. Special editions, including personalized covers, corporate imprints, and excerpts, can be created in large quantities for special needs. For more information, contact the publisher.

We are always looking for people to write books on new and related subjects. If you have an idea for a book, please contact us at proposals@schifferbooks.com.

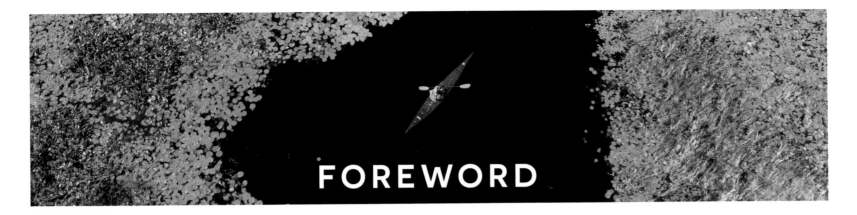

FOREWORD

BY BILL McKIBBEN

Occasionally I think I'd like to come back as a hawk, and Caleb Kenna's photos have confirmed for me the wisdom of my choice.

We take our particular vantage point for granted—the world appears to us usually from a height of 5 or 6 feet, and viewed more or less ahead. But that's just, as we'd say now, privileging our anatomy. Now that technology lets us easily borrow the tools of other species—the drone is precisely what we'd call an "eagle eye"—we can begin to see what fun they've been having all along.

Because Vermont from up top turns out to be magical. The window of a jet is too high to really appreciate the play of shadow, depth, and dimension that Kenna captures so powerfully here. Suddenly you realize what a shadow is, in a way you haven't before.

The scars of our civilization acquire a bit of grace in these pictures—roads can sweep, and the slightly jumbled geometry of, say, shrink-wrapped yachts waiting for summer looks much sweeter from on high. (The visual joke of the schoolbus-shaped hole in the snow made me start, and then laugh out loud.) Vermont's natural landscape is even more beautiful, of course—here you get the sinewy shoulders of our ridgelines, the crowns of the trees we're used to seeing spread out above us. And then there are the images that show the collaboration between landscape and imagination: whoever took the time to stomp out those spirals in the snow is a real artist!

And of course that reminds us what a fine artist Kenna is. The framing of these images shows a rare and gifted eye—especially since that framing comes in three dimensions. Unlike most photographers, he needs to figure out how high the material demand that he send his camera.

Pixel per acre, I can't think of a more diverse landscape than Vermont's: alpine mountaintops a few miles from Midwest-flat fields a few miles from the shoreline of our great lake. What a gift we've been given to see it from a new vantage!

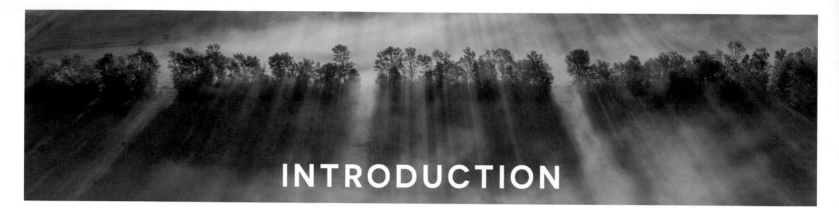

INTRODUCTION

Ever since I was a kid, I've loved to fly in airplanes. Airplanes meant journeys of discovery, visions of new lands as I gazed out an oval window at an ever-changing view of the world. These days, I discover new visions in familiar landscapes. Instead of an airplane window, I fly above Vermont, looking for patterns on the land through the lens of a drone.

As photographers, we often look for new ways of seeing familiar landscapes. We are always looking for new perspectives, whether from the top of a ladder or the summit of a mountain. I am drawn to the idea of equivalence, photographs as metaphors for beauty, mystery, and wonder.

I started using a drone several years ago to make aerial pictures above Vermont, mostly in the Champlain Valley. At first, I flew as high as possible, to nearly 400 feet, and photographed familiar landscapes from above. Making pictures with a drone became a kind of meditation, a daily act of aerial discovery. Driving through the Mettowee River valley of southwestern Vermont, I spotted the roof of an old barn in the middle of a cornfield. Launching my drone, I found a pattern of corn rows surrounding the weathered barn with a slate roof. By pointing the drone's camera straight down, I discovered my preference for a bird's-eye view. Without the horizon, landscapes become more about patterns, abstraction, and visual mystery. Using a drone to frame the world has made me appreciate even more not only bright, sunny days and their long shadows, but also cloudy, gray days with the sky like a huge diffuser above an ever-changing palette of Vermont's colors.

Vermont is known for its rolling hills, working farms, and conserved forests and rivers. I live in the Champlain Valley, known as the land of milk and honey because of its dairy farms and apiaries. Apple orchards dot the surrounding landscape. Rivers and lakes provide rejuvenation, recreation, and tranquility. Trees and tractor tire impressions demarcate Vermont's agricultural past and current practices. Quarries, railyards, and scrap metal lots prove that Vermont's is a real working landscape and not just for bucolic picture postcards. Solar arrays hint at the state's renewable future.

Vermont's seasons and weather provide the cadence, color, and rhythm to this collection of aerial photographs. Most every day, I try to get outside, launch my drone into the skies, and look to capture new views of the Green Mountain State. I love flying during the golden hours around sunrise and sunset as the landscape below awakens or prepares for the passing of another day. With my pictures I mark the passage of time, of seasons, and of patterns, settlement, and yearly renewal. Drone photography provides a sense of soaring, freedom, and discovery and reminds me of flying in airplanes, or more like a bird, looking down with fresh eyes on the landscape below.

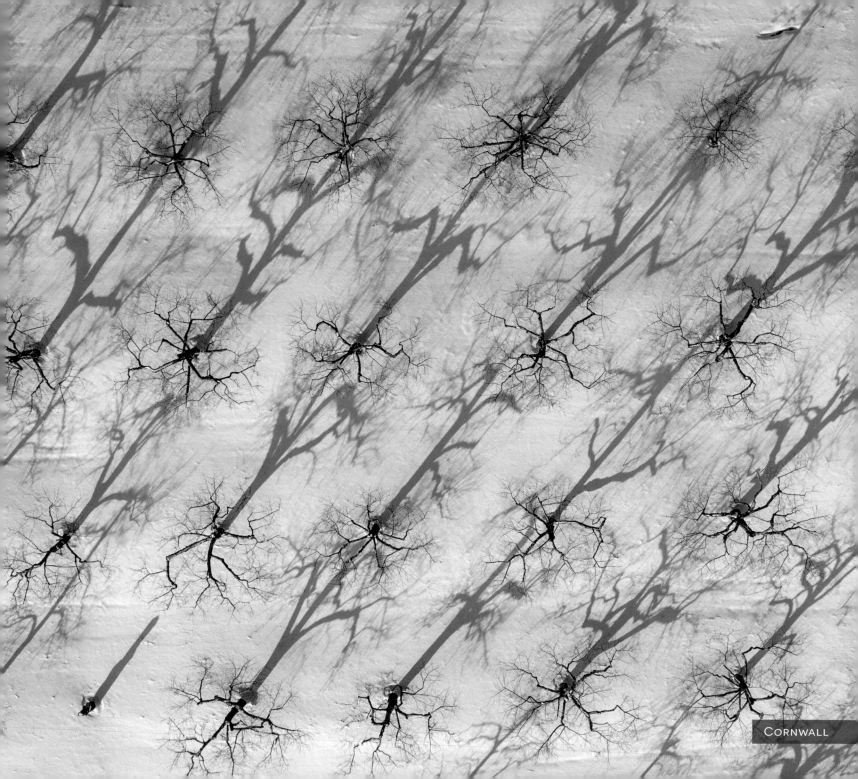

Cornwall

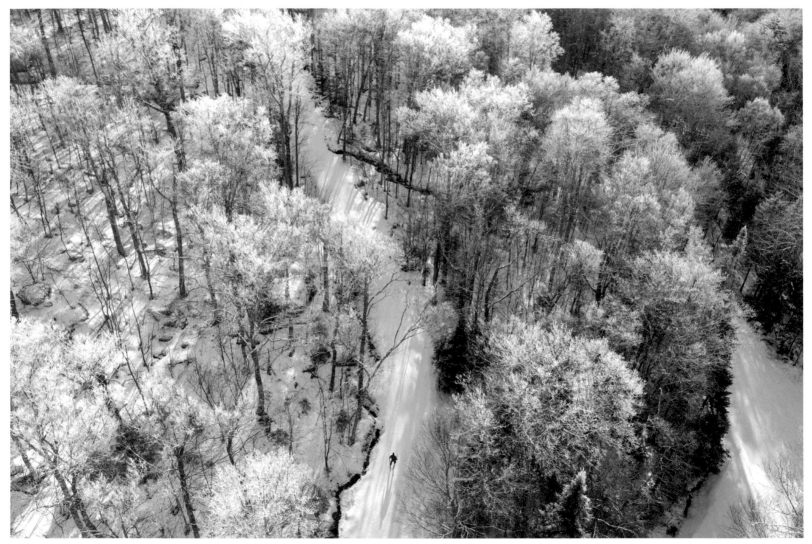

WOODFORD

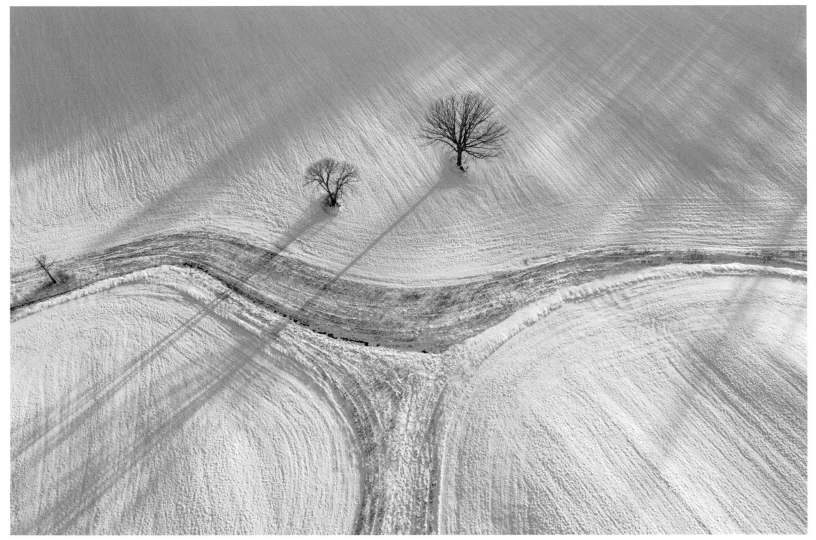

WEYBRIDGE

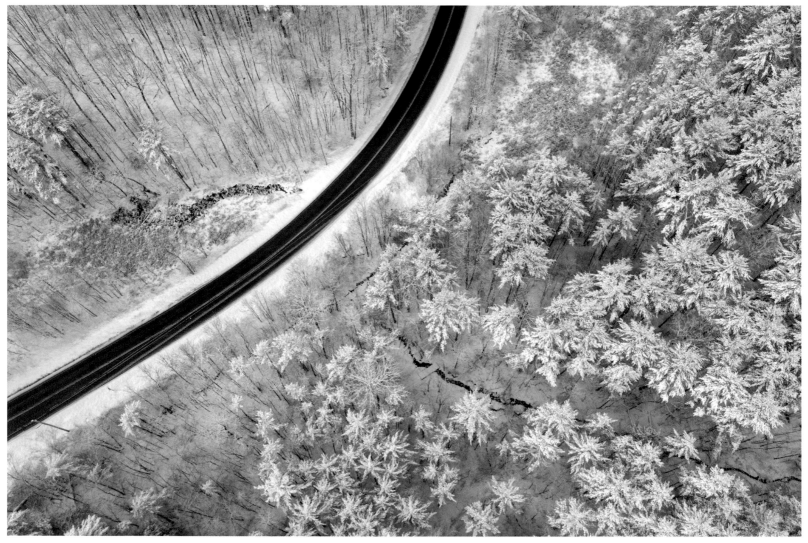

MIDDLEBURY

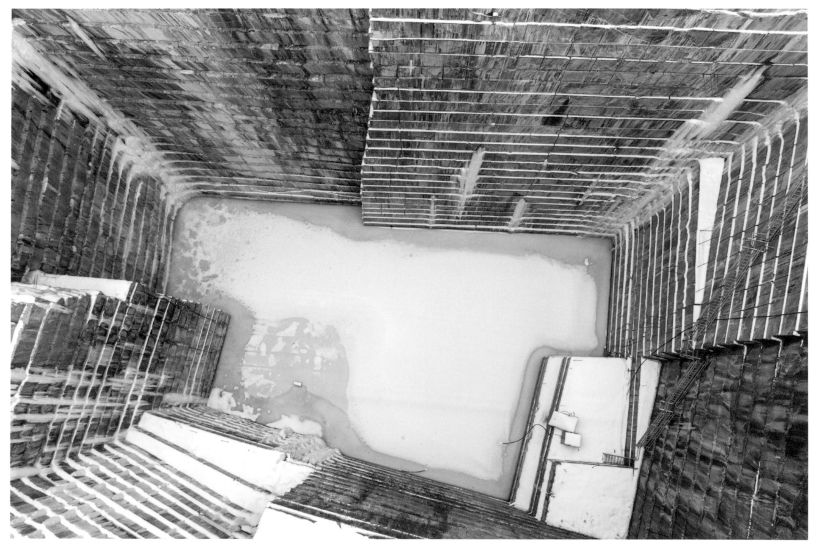

ROCHESTER

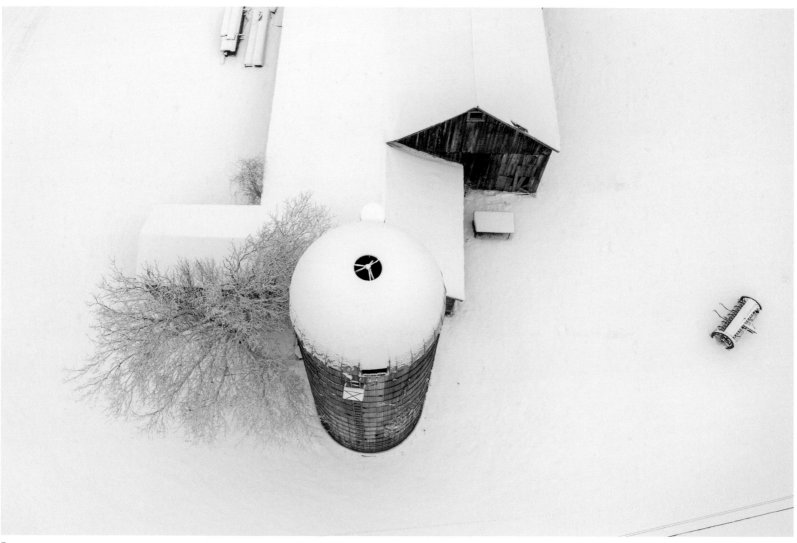

BRISTOL

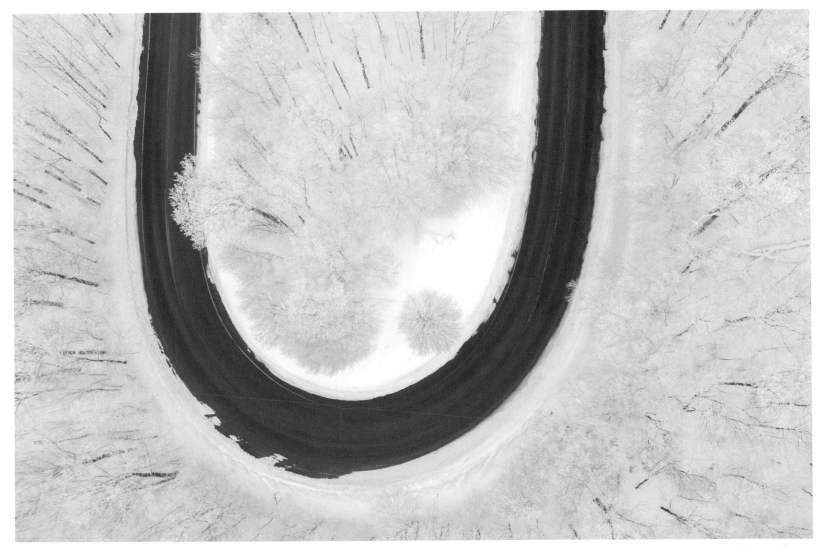

BUELS GORE

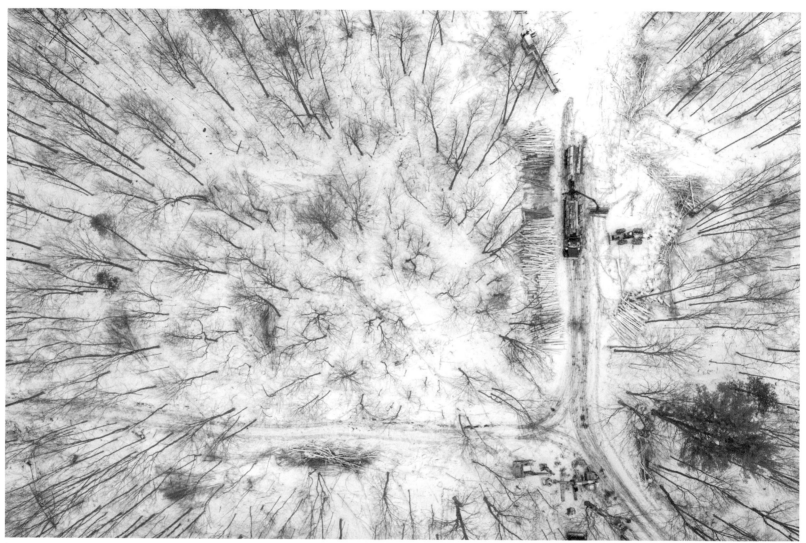

BRANDON

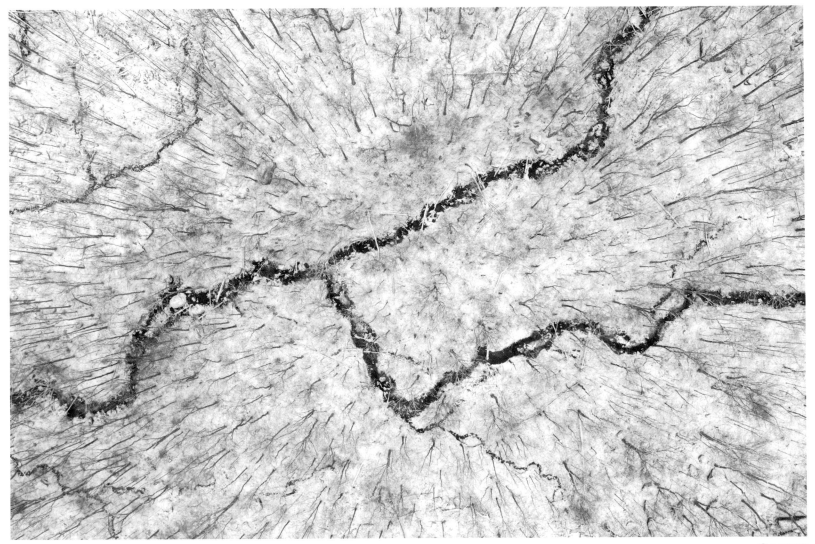

GOSHEN

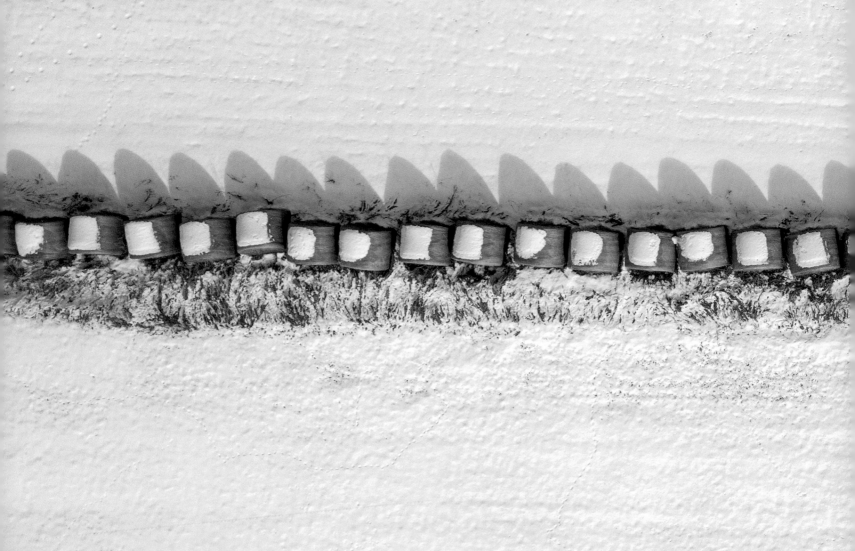

Bridport

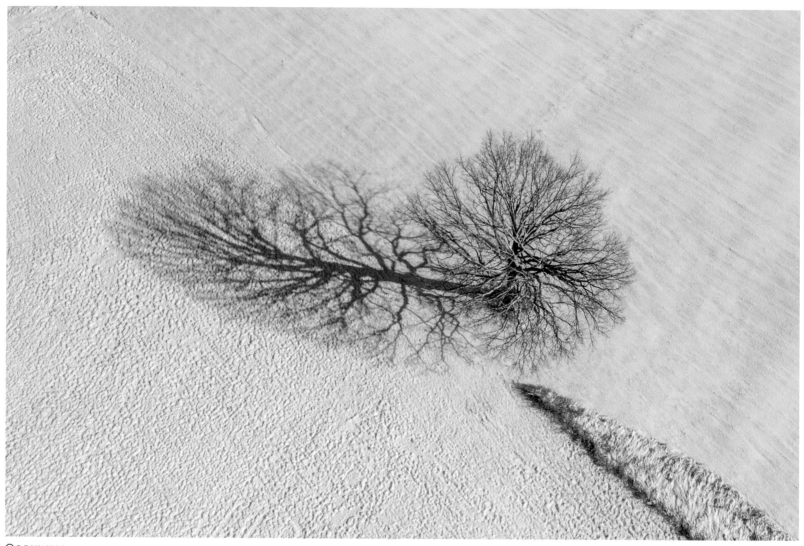

CORNWALL

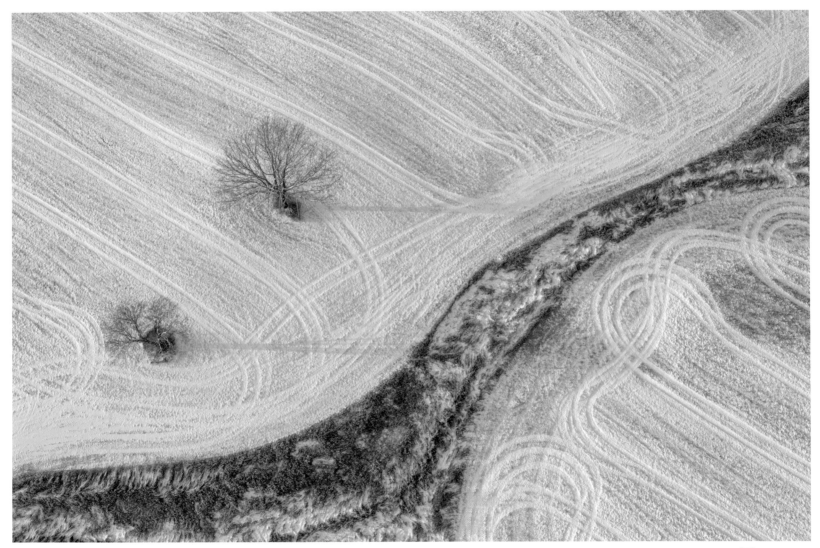

WEYBRIDGE

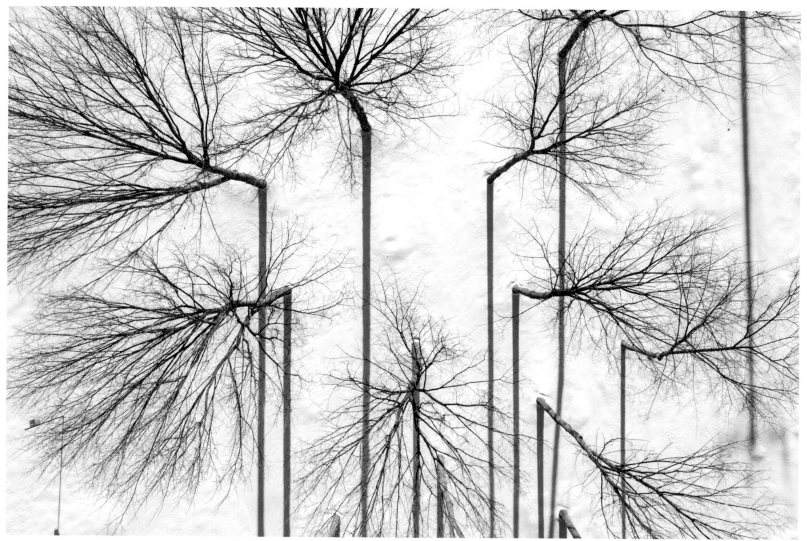

SUDBURY

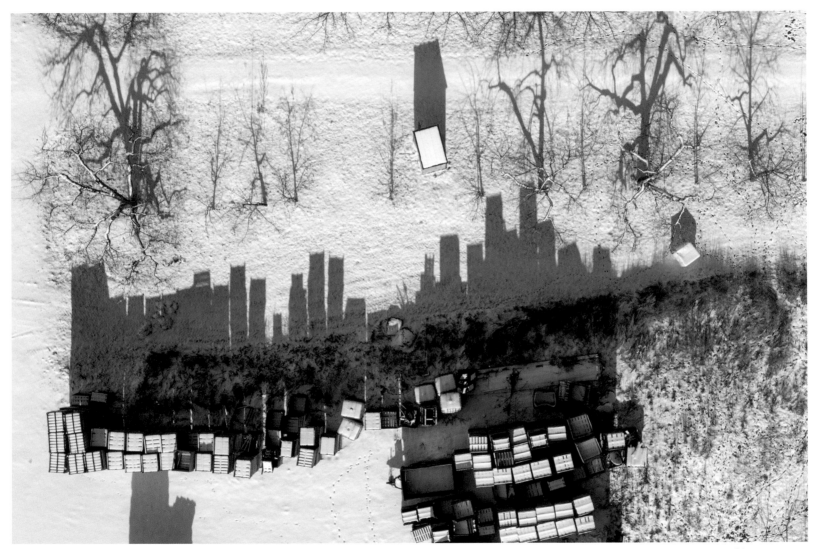

MIDDLEBURY

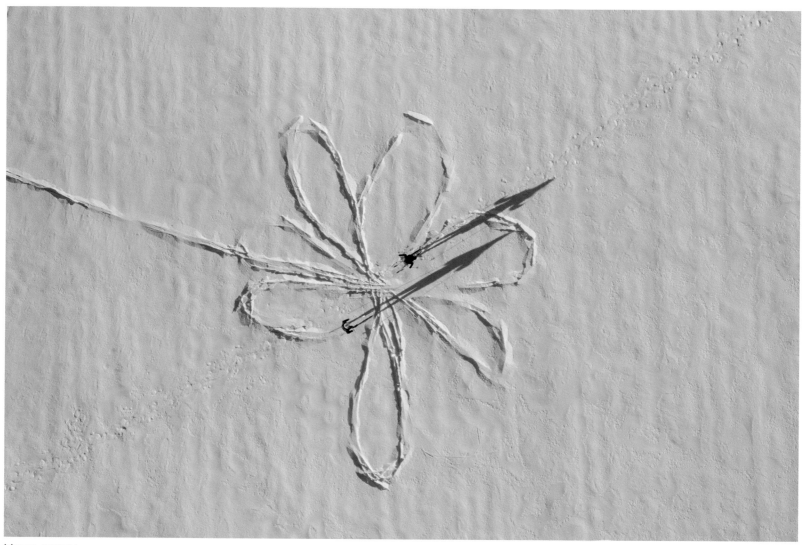

MIDDLEBURY

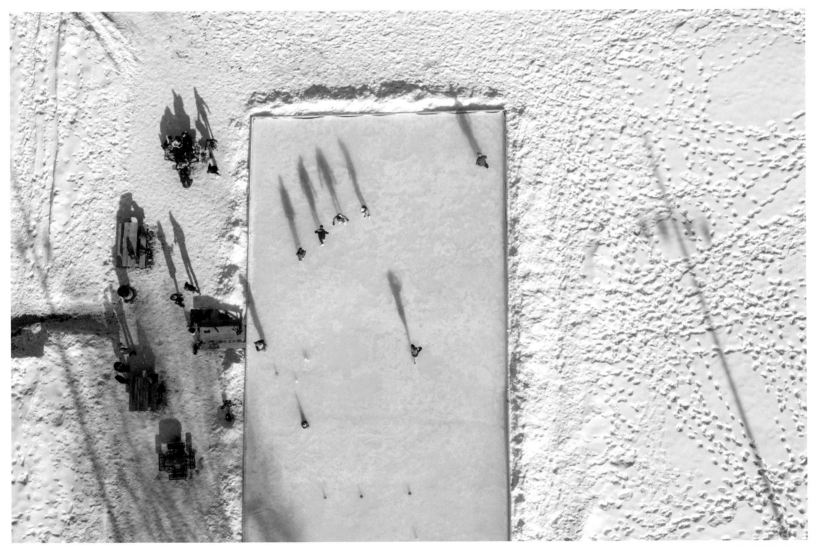

MIDDLEBURY

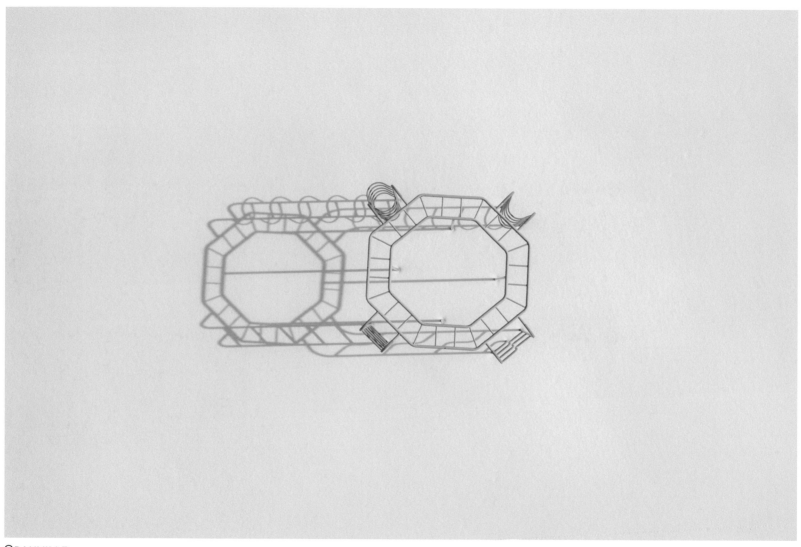

GRANVILLE

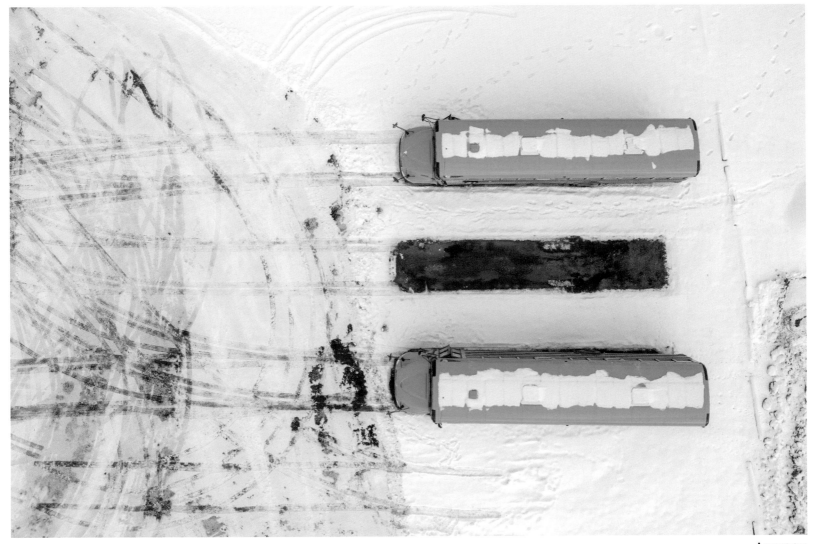

ADDISON

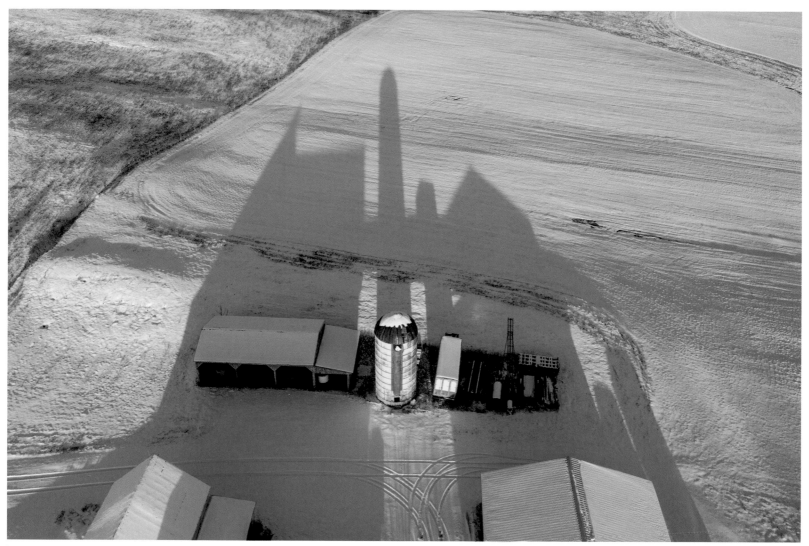

WEYBRIDGE

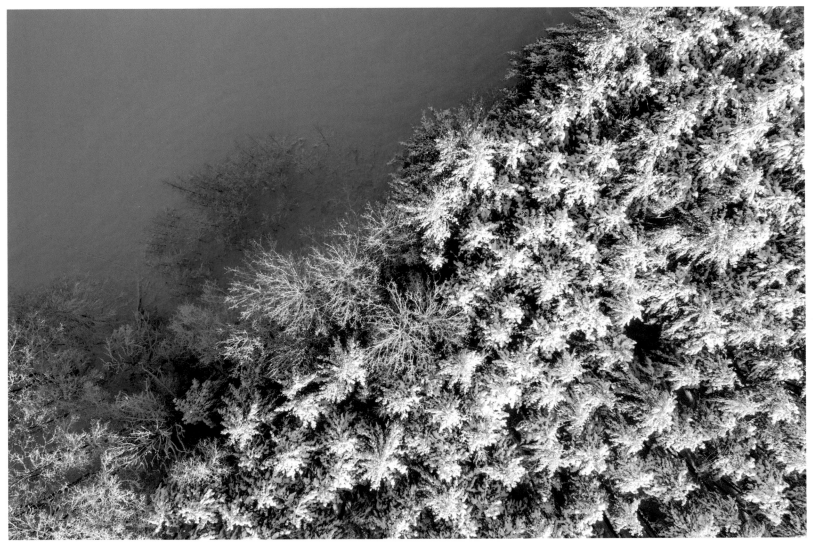

BRANDON

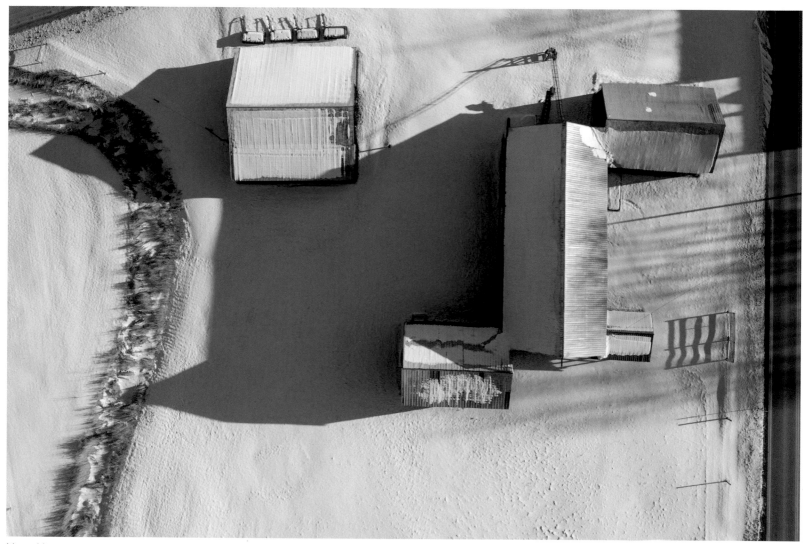

New Haven

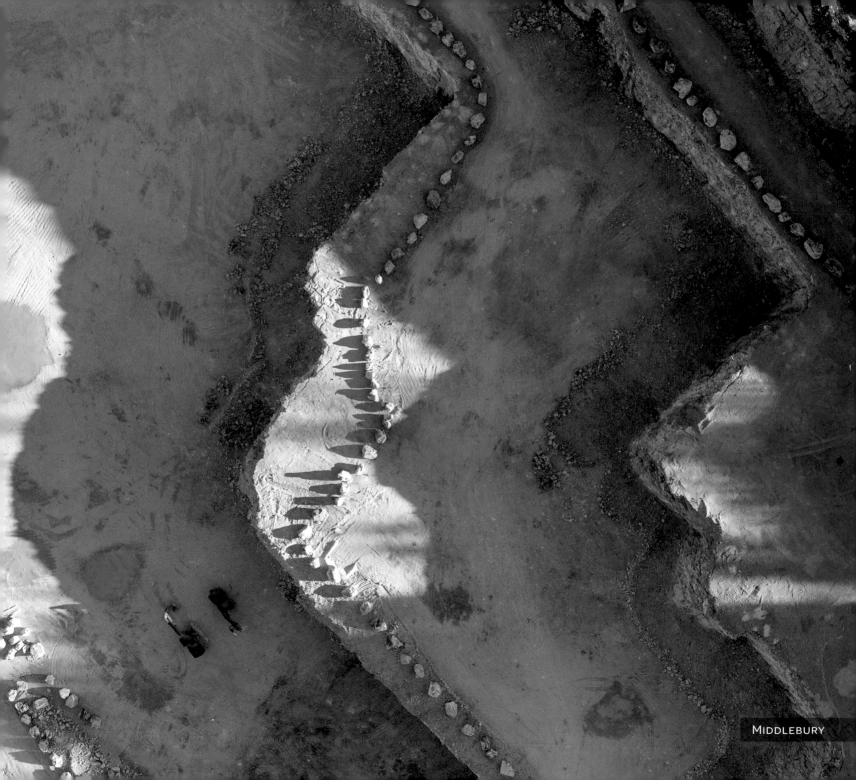
Middlebury

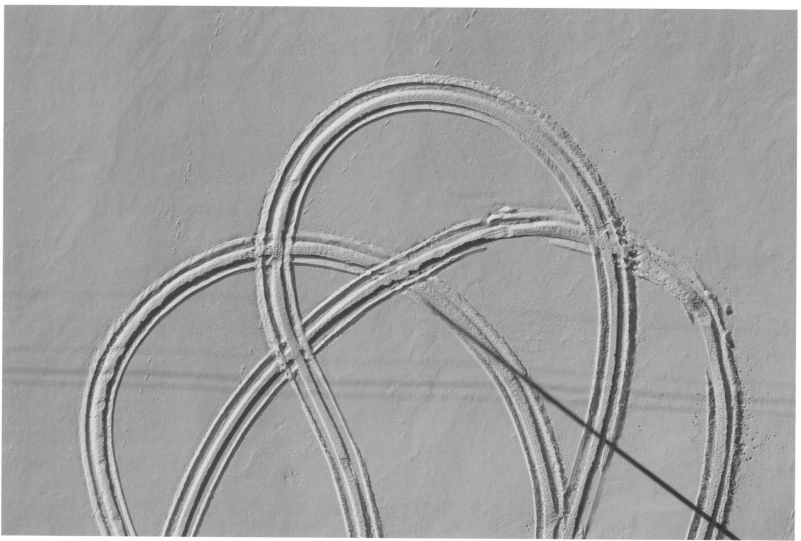

STARKSBORO

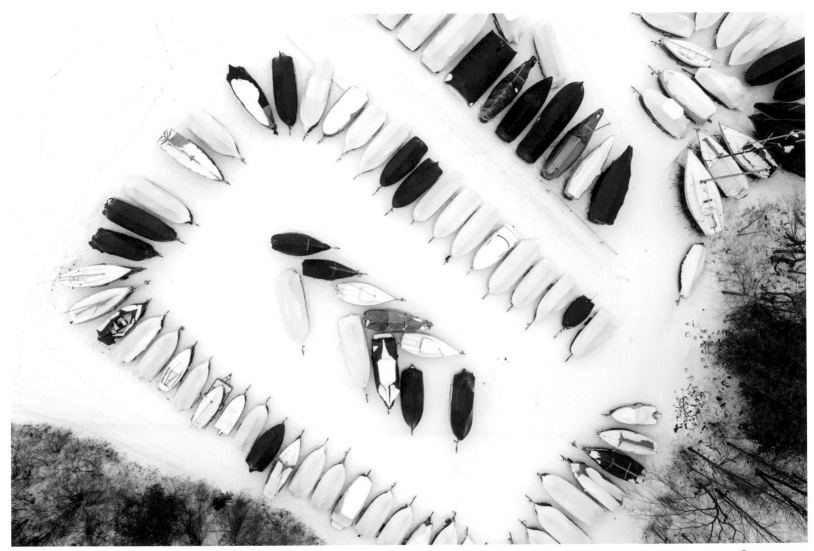

CHARLOTTE

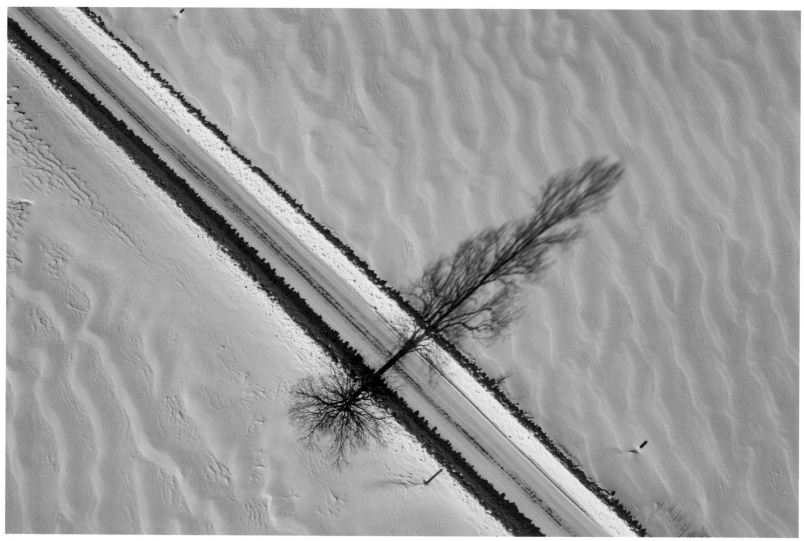

ORWELL

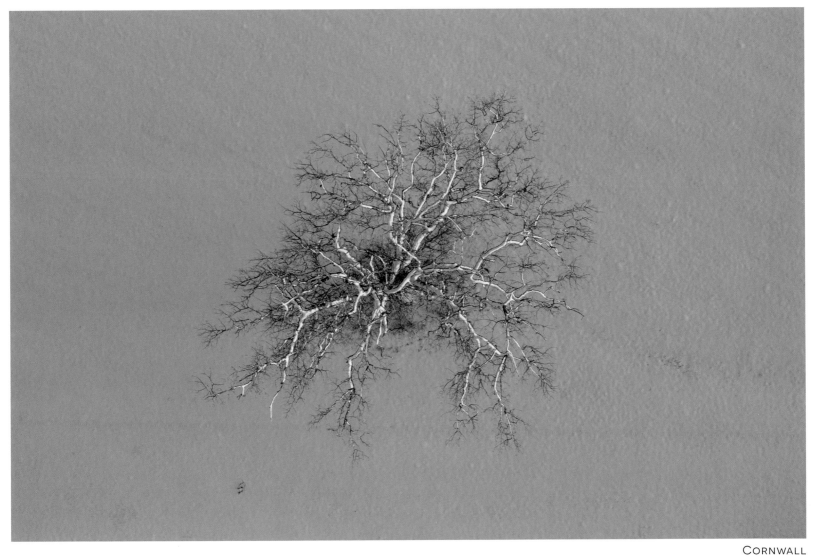

CORNWALL

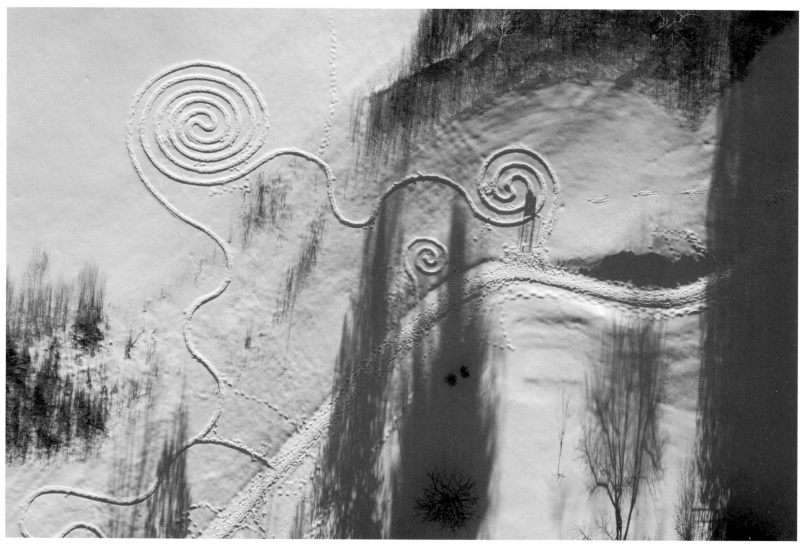

MIDDLEBURY

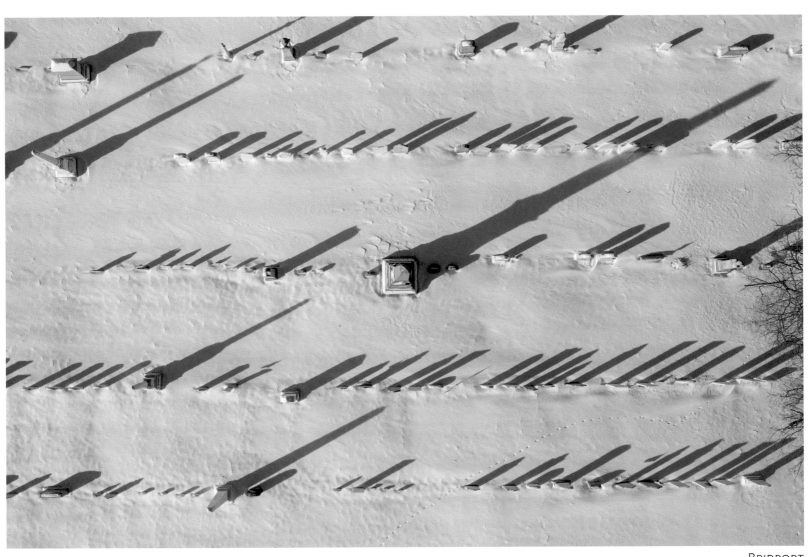

BRIDPORT

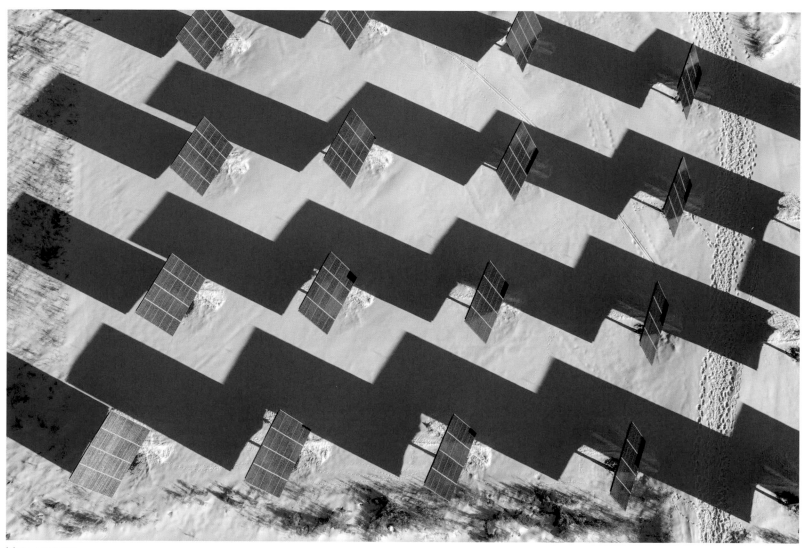

MIDDLEBURY

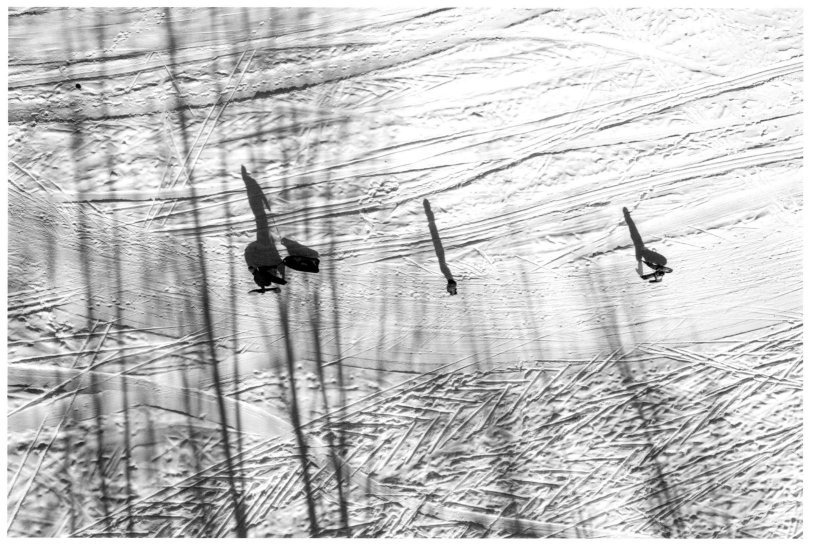

MIDDLEBURY

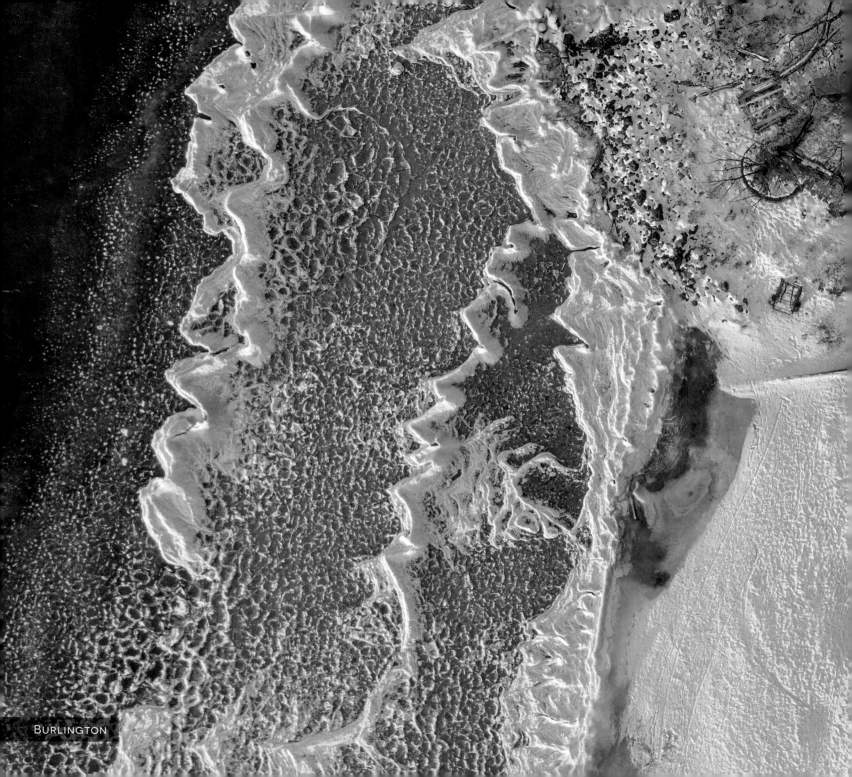

BURLINGTON

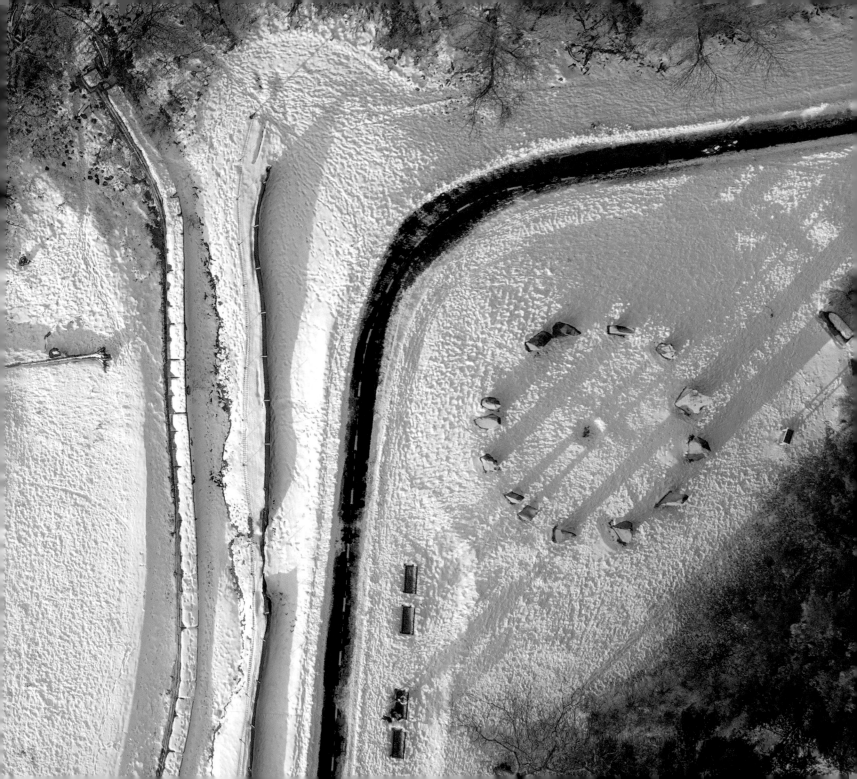

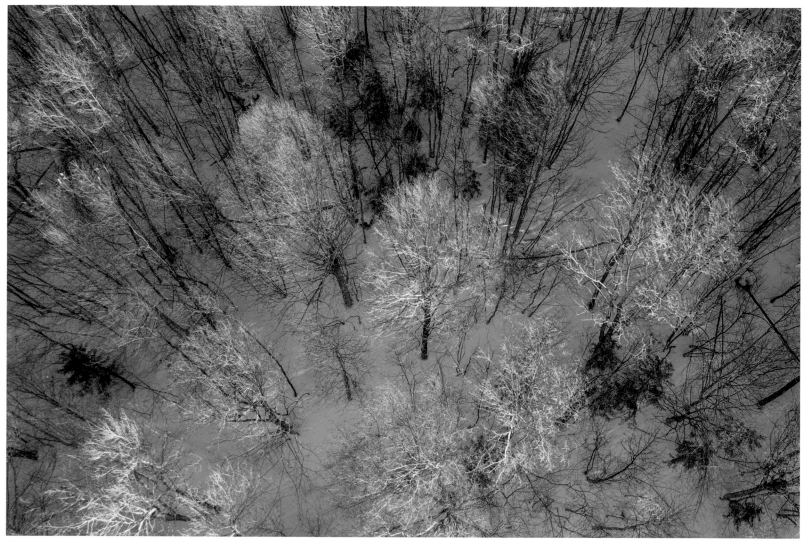

GOSHEN

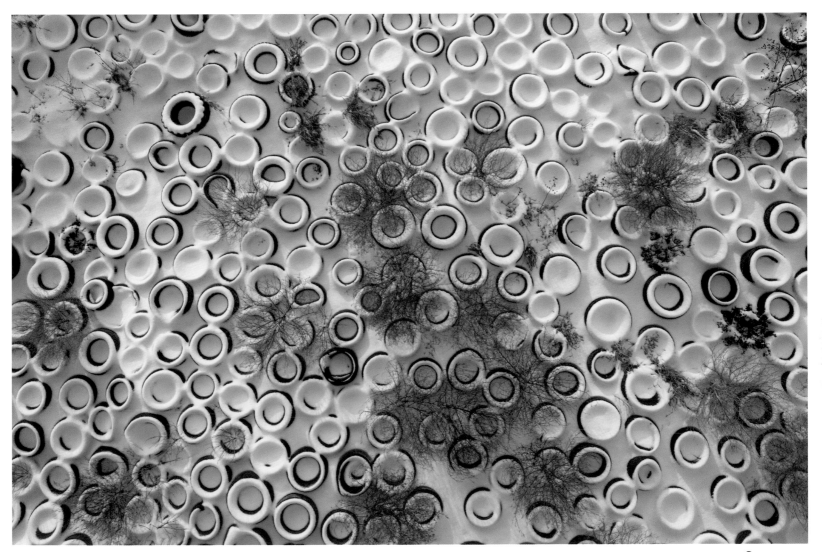

CORNWALL

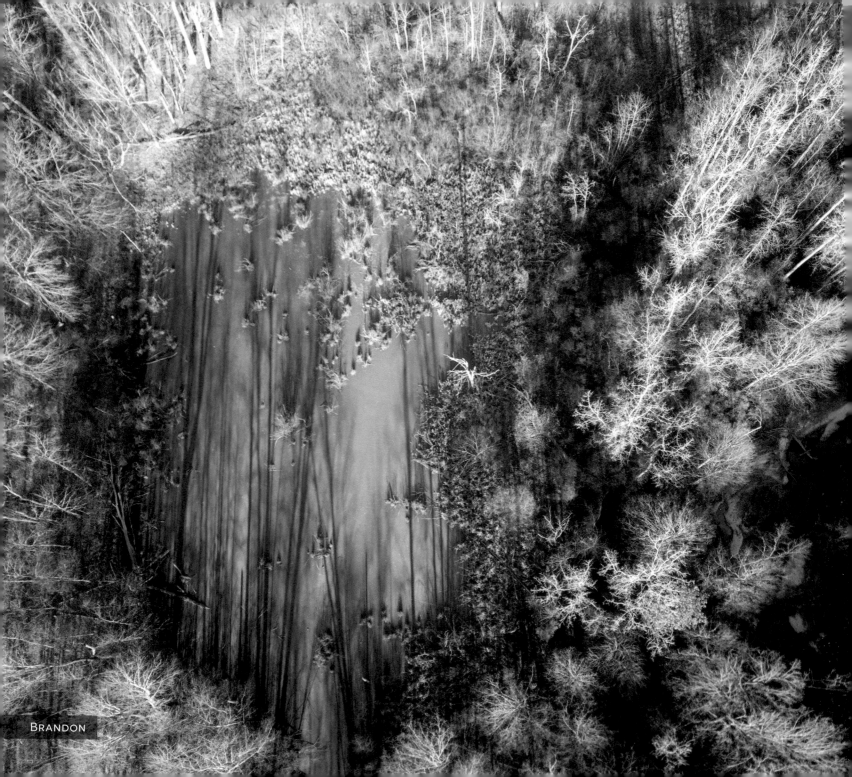

BRANDON

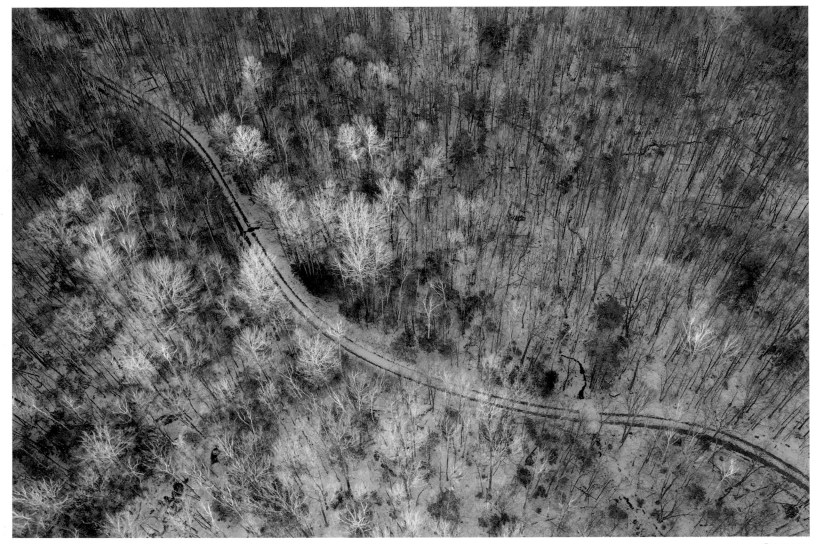

GOSHEN

MIDDLEBURY

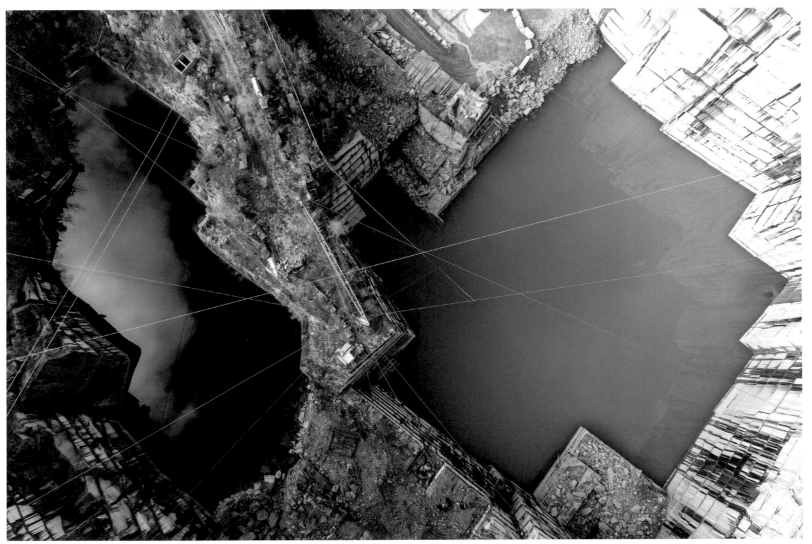

GRANITEVILLE

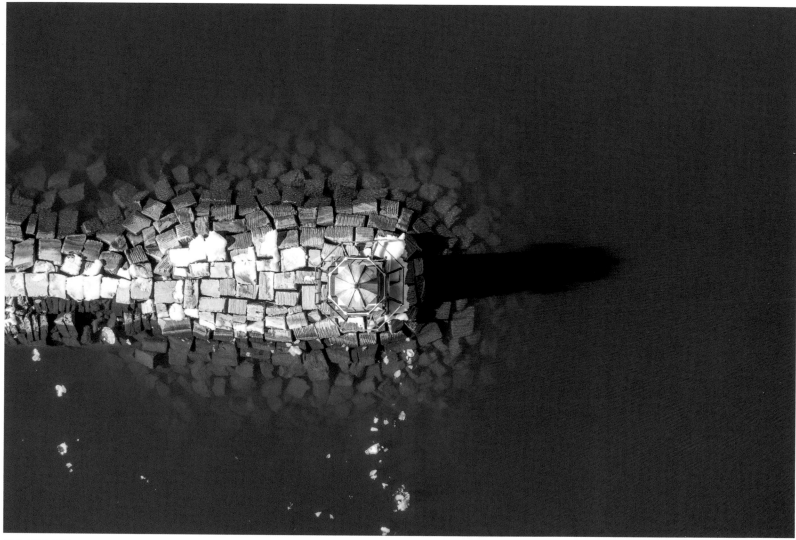

BURLINGTON

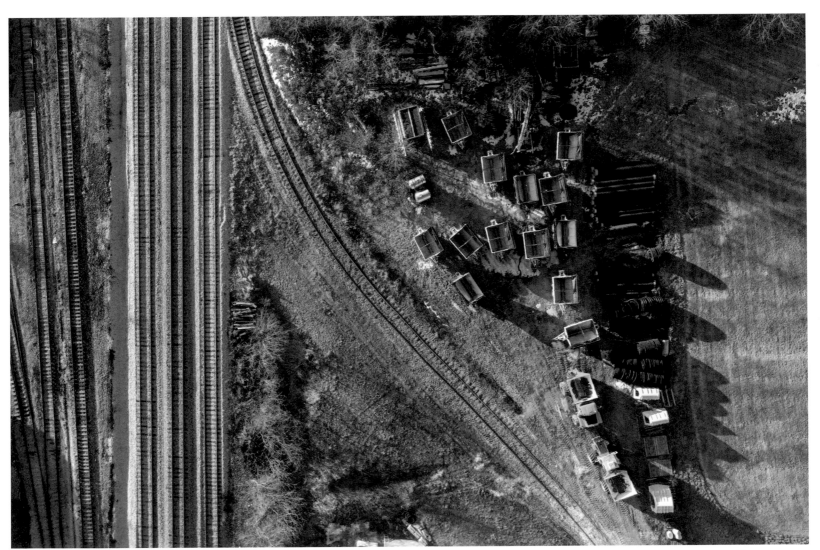

MIDDLEBURY

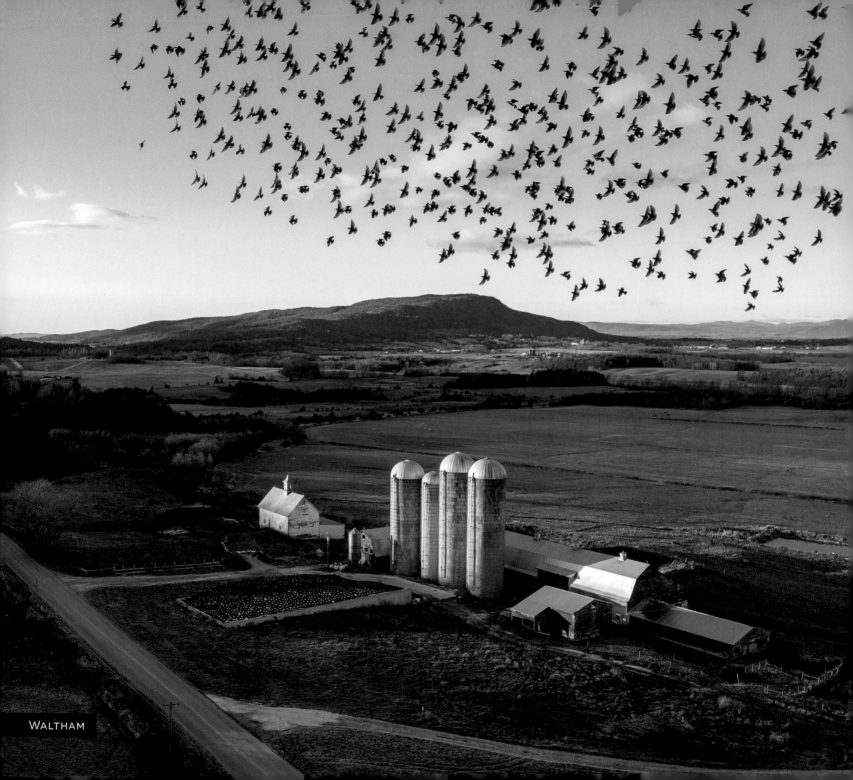

Waltham

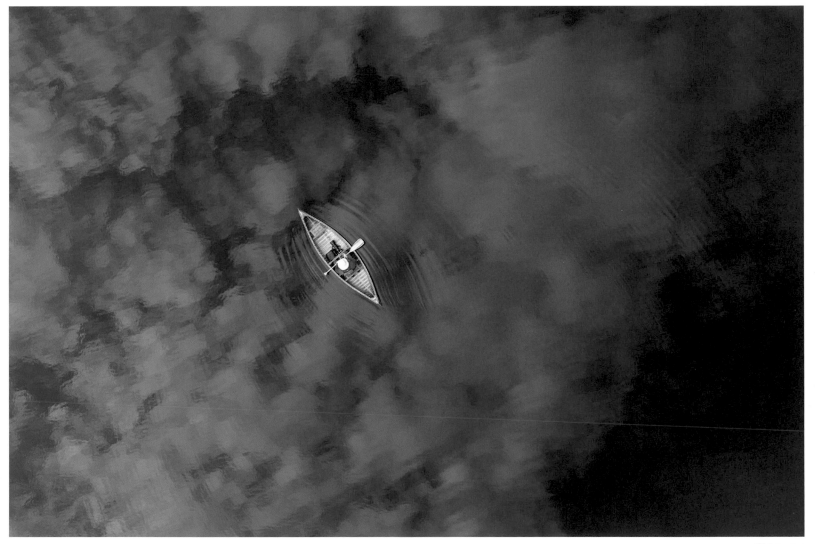

GOSHEN

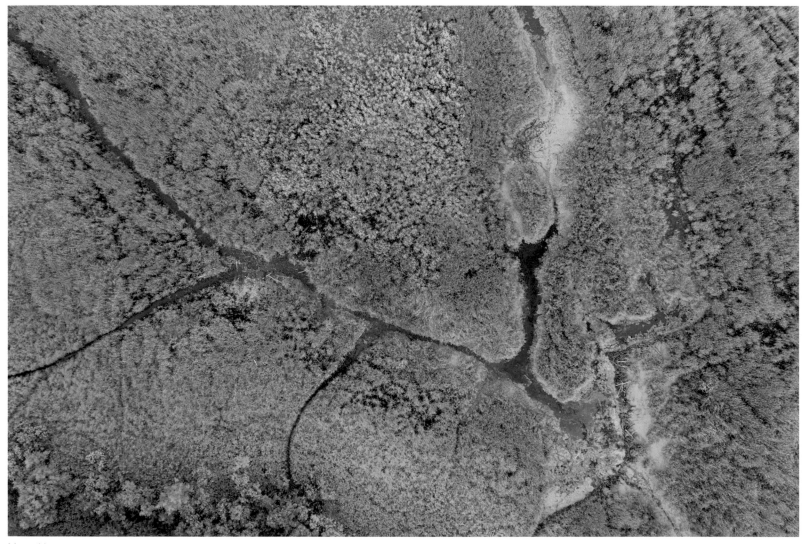

New Haven

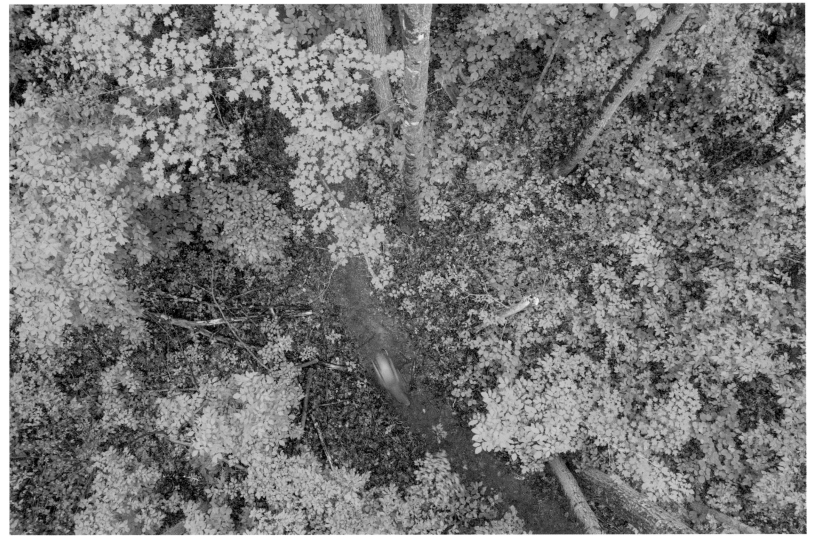

WEYBRIDGE

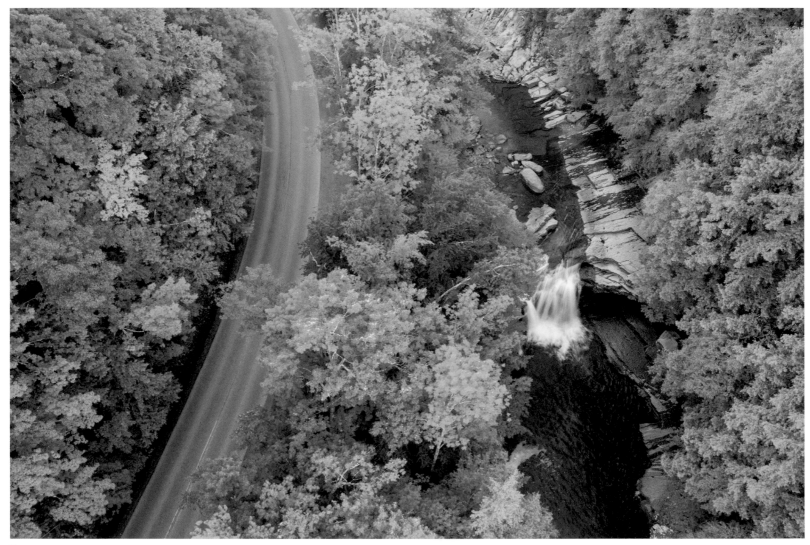

Bristol

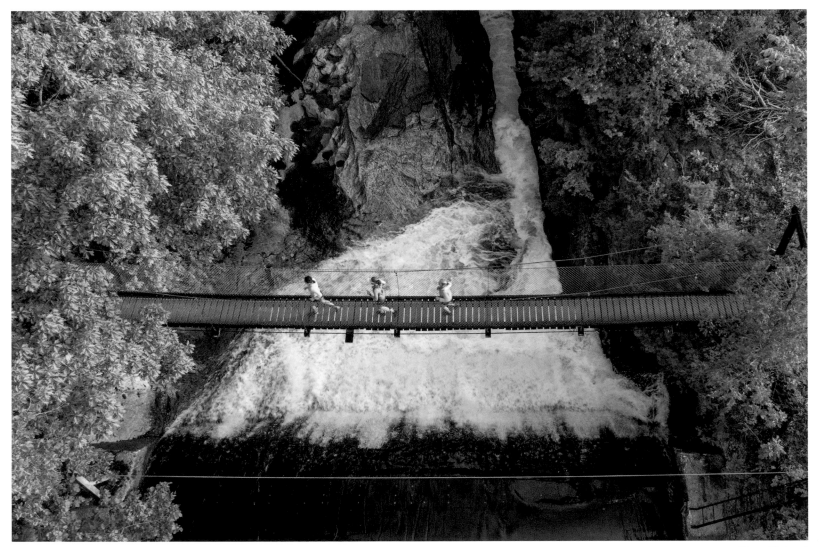

NEW HAVEN

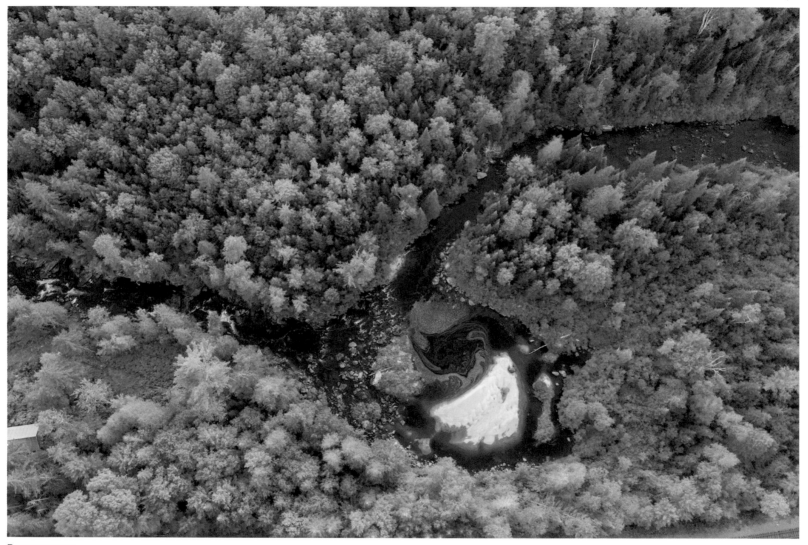

BRUNSWICK

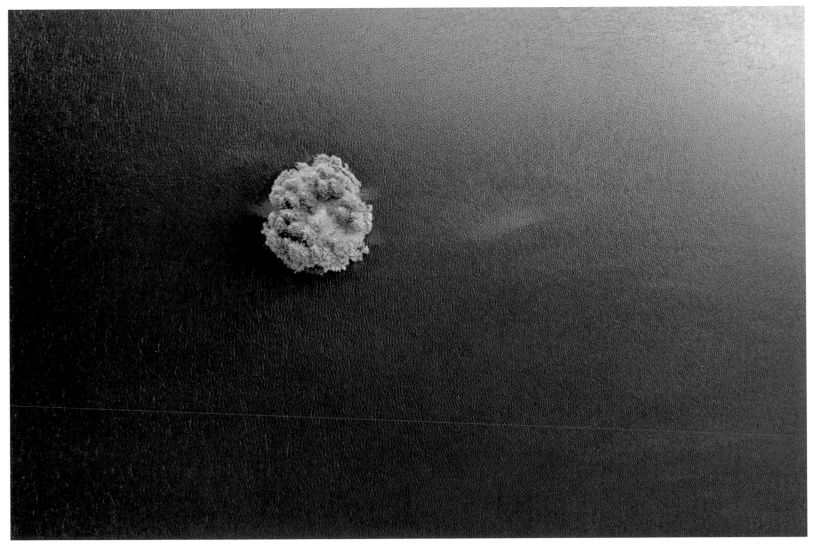

WARREN

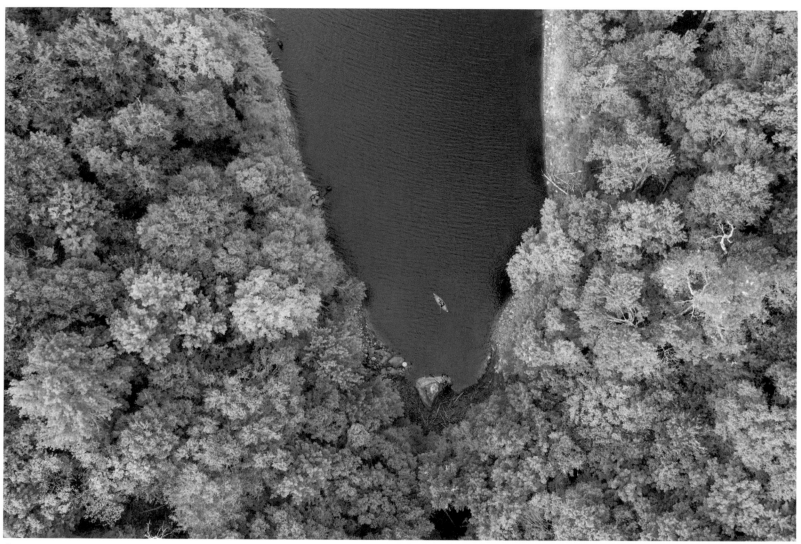

GOSHEN

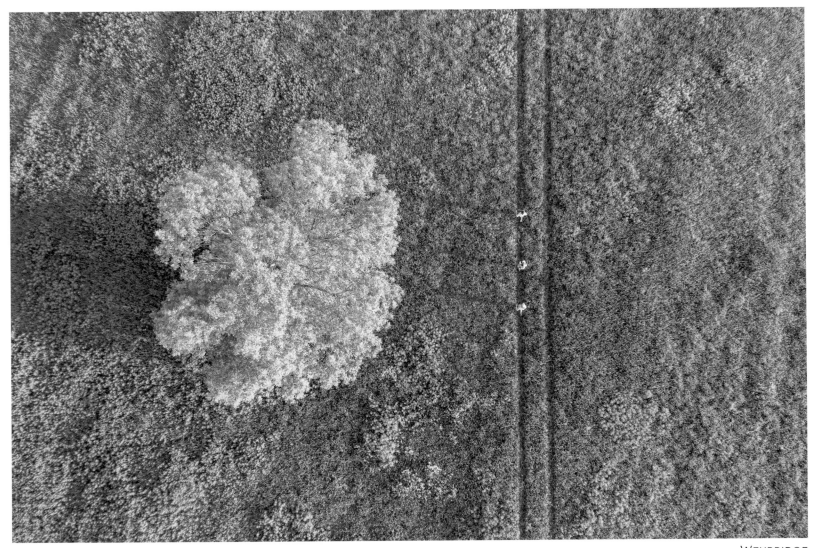

WEYBRIDGE

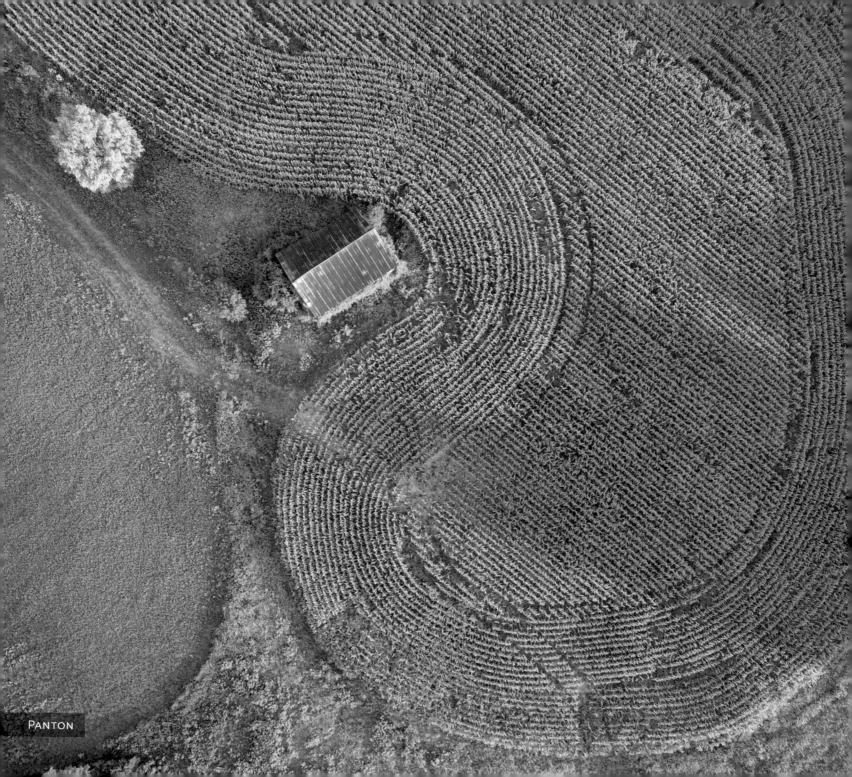

PANTON

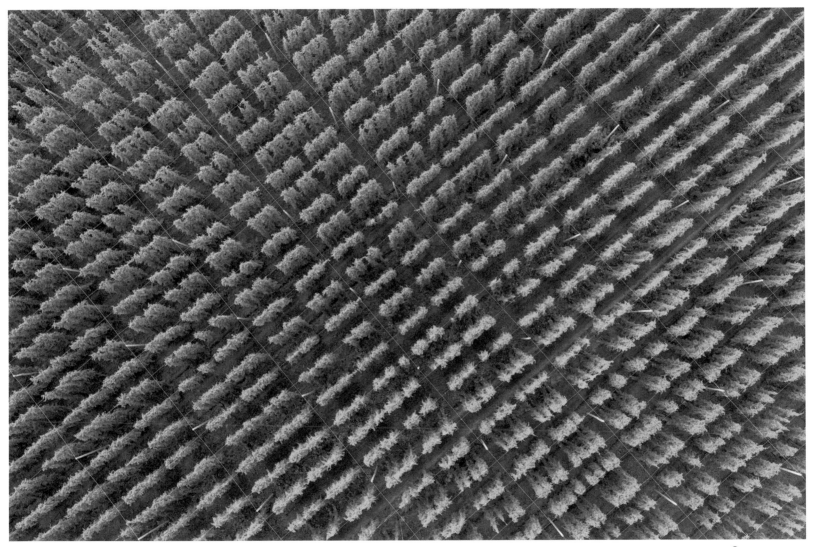

STARKSBORO

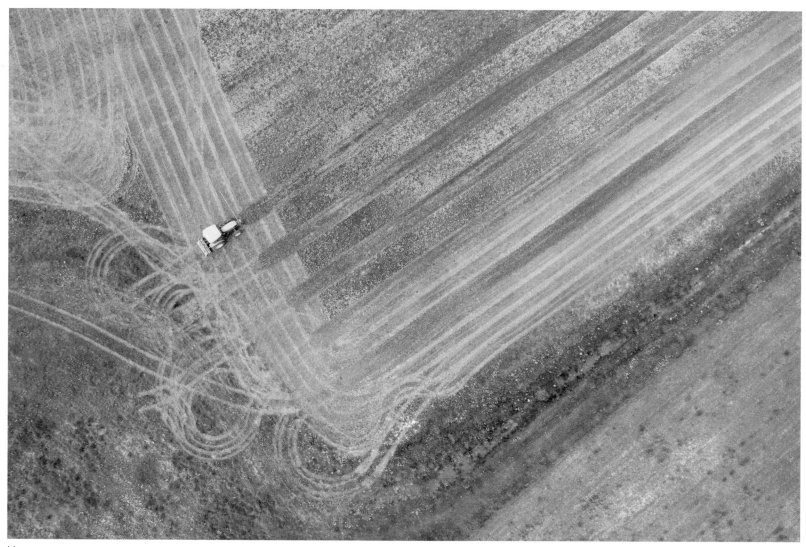

HINESBURG

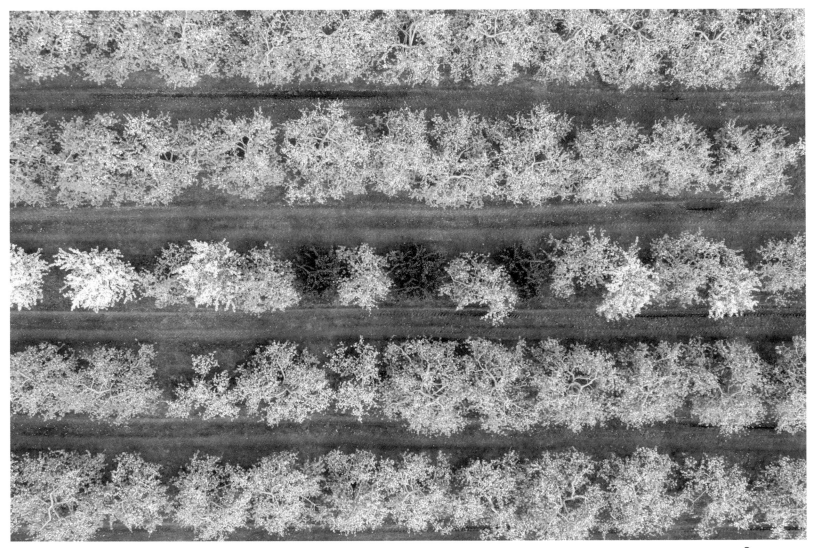

SHOREHAM

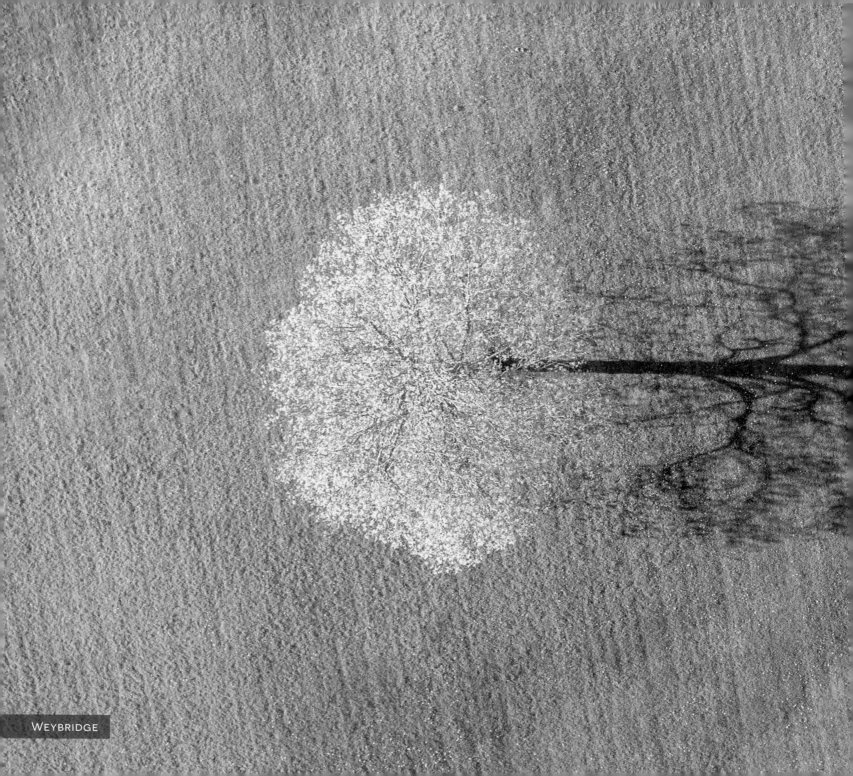

WEYBRIDGE

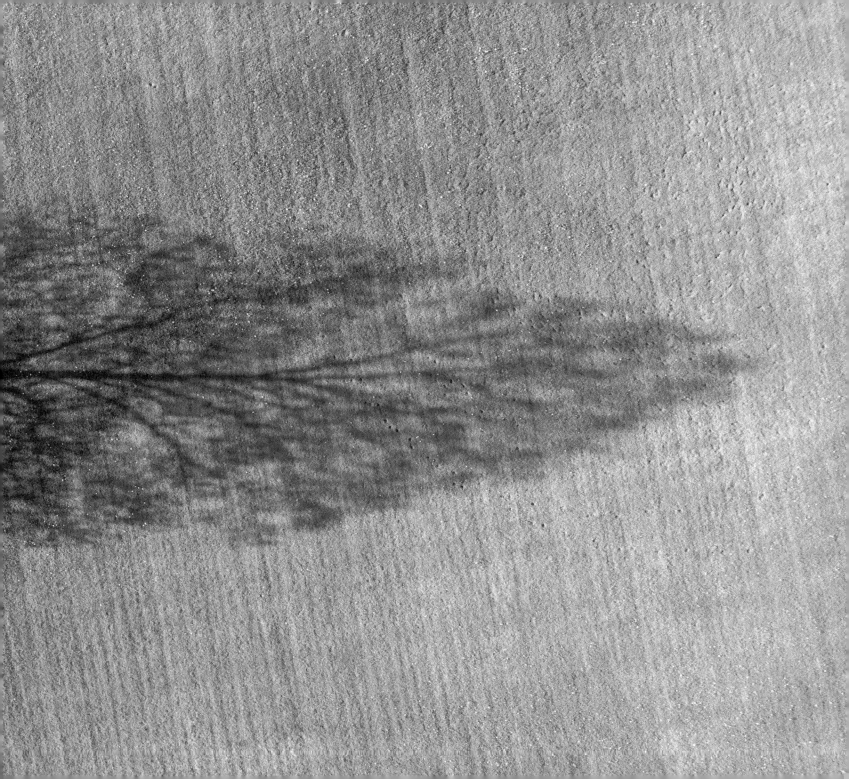

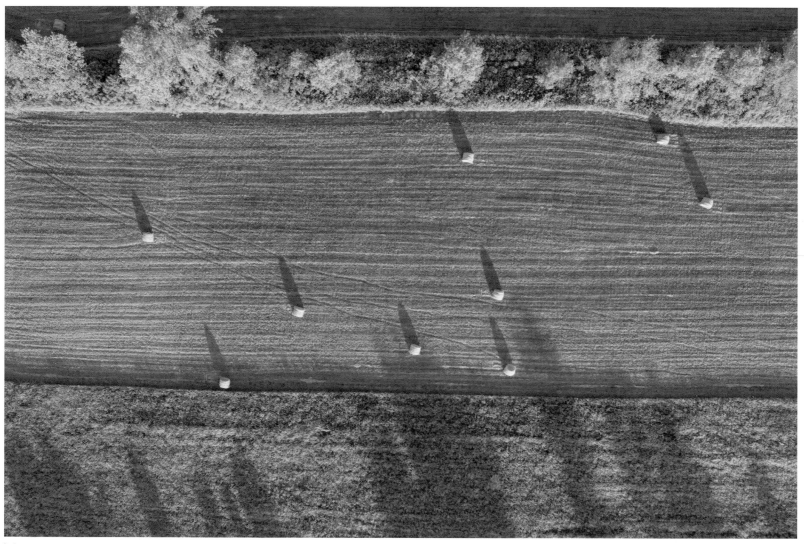

Whiting

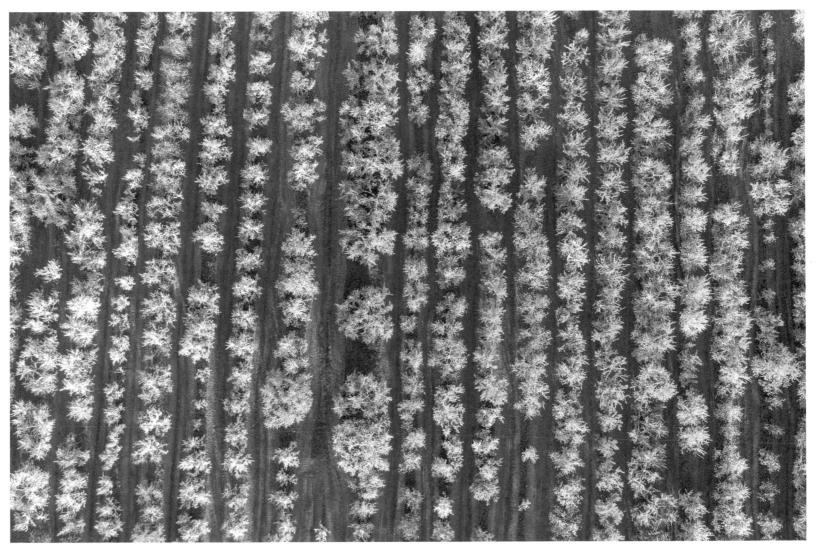

MIDDLEBURY

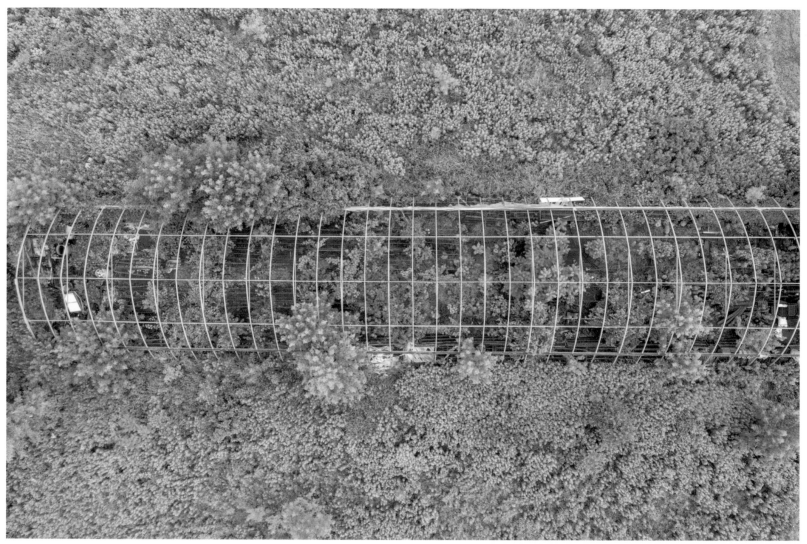

FERRISBURGH

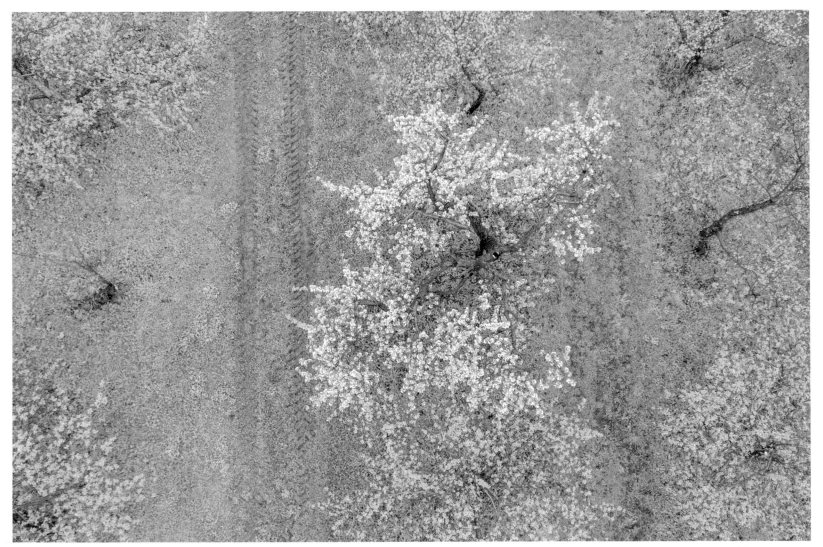

MIDDLEBURY

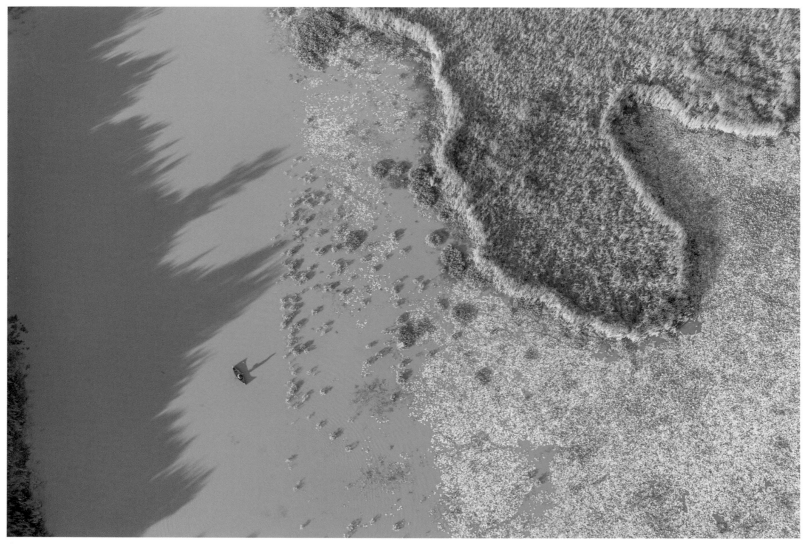

ADDISON

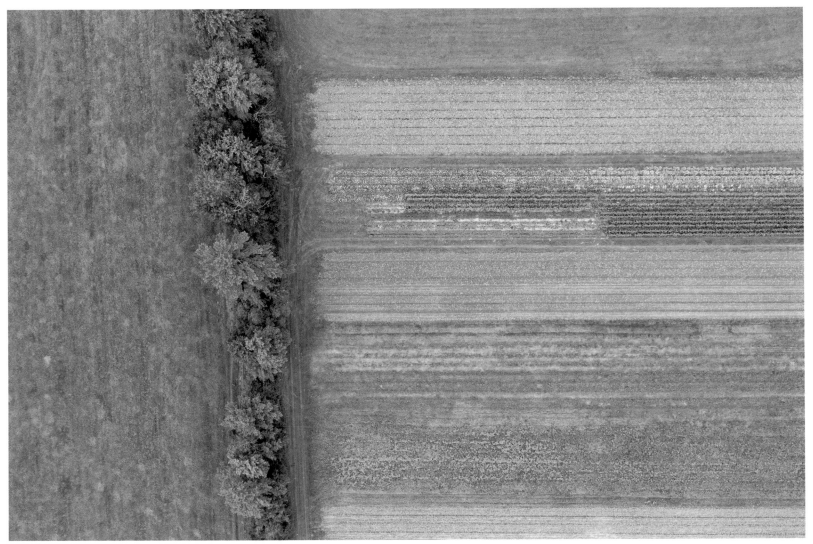

MIDDLEBURY

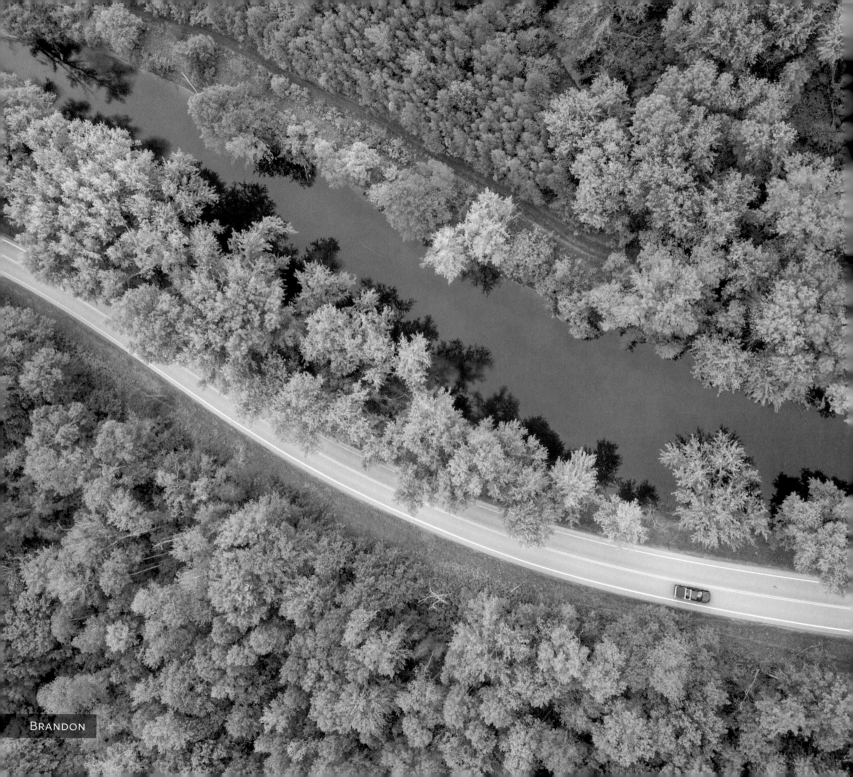

BRANDON

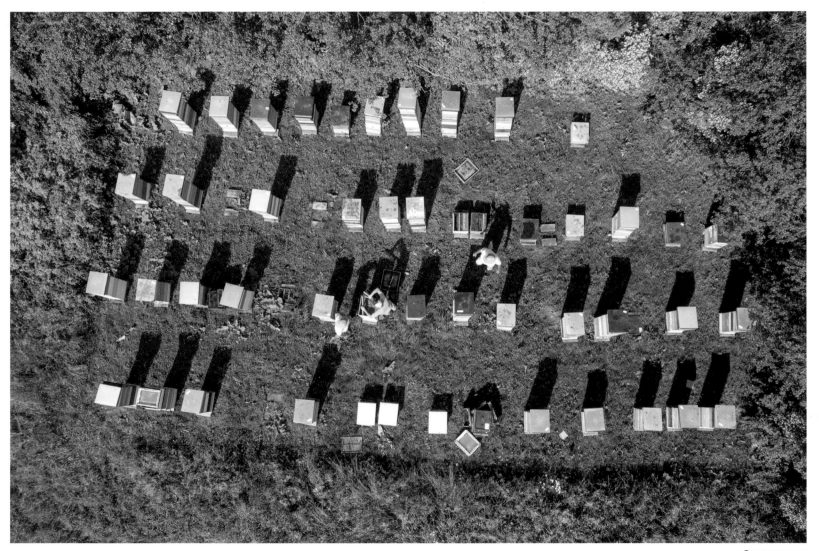

SHOREHAM

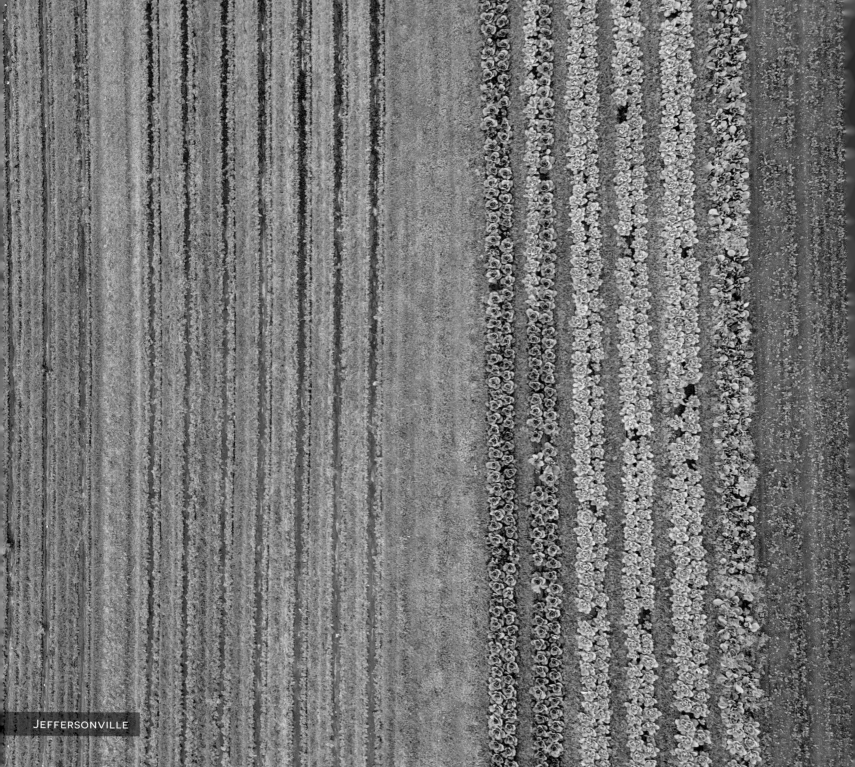

JEFFERSONVILLE

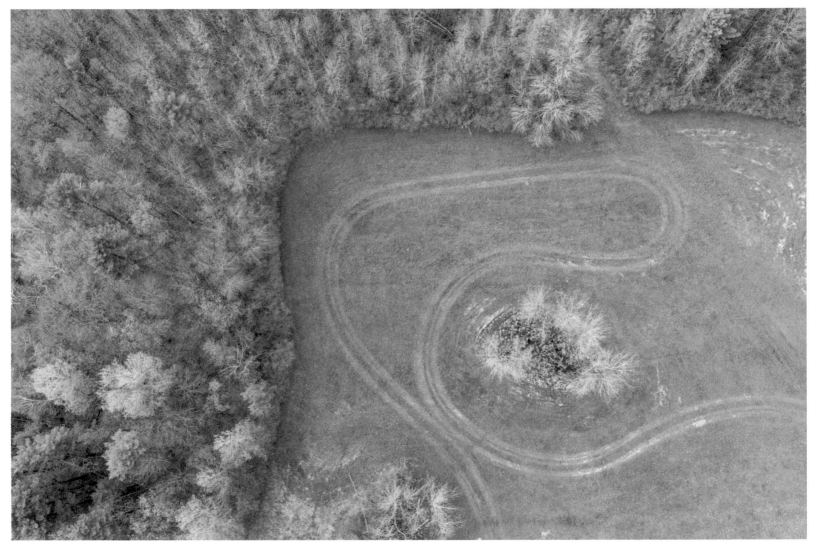

WEYBRIDGE

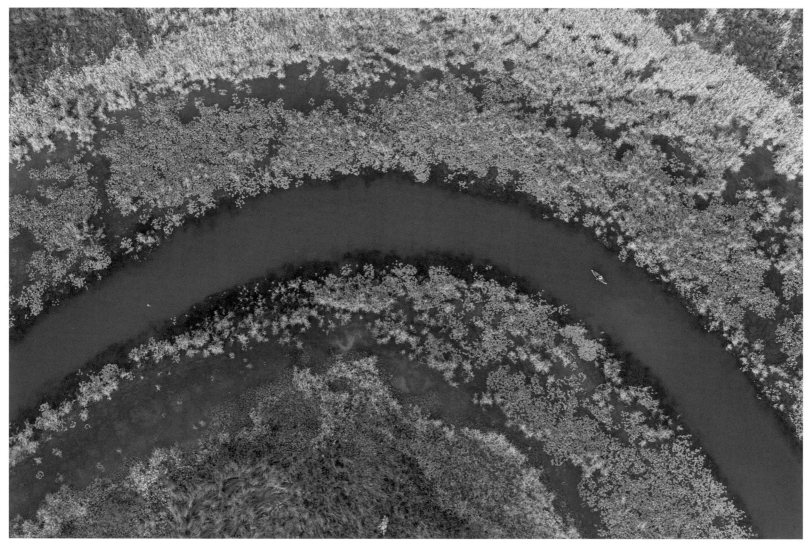

FERRISBURGH

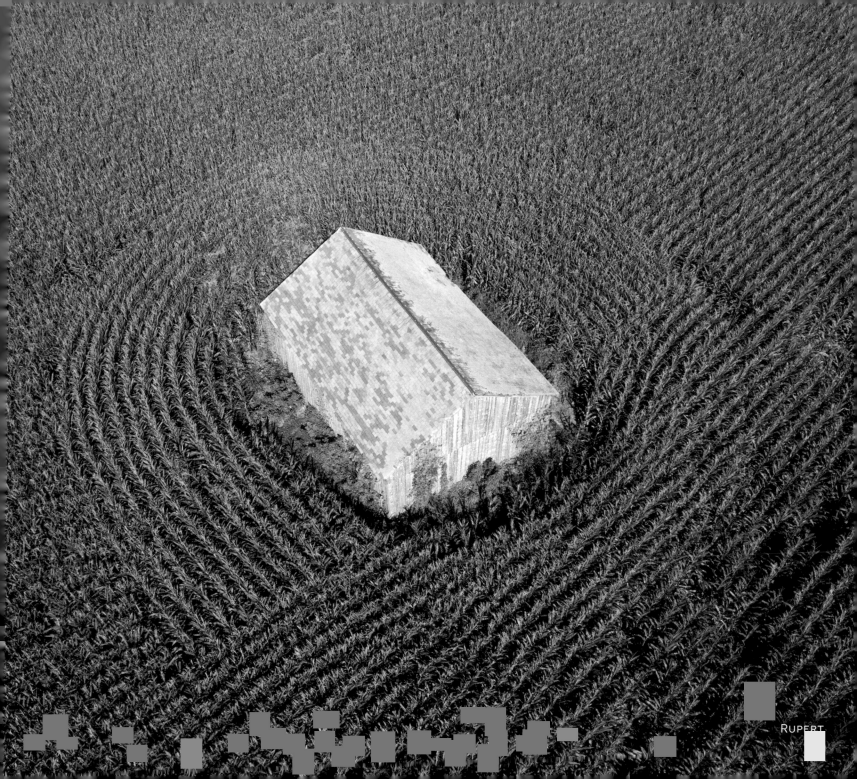

Rupert

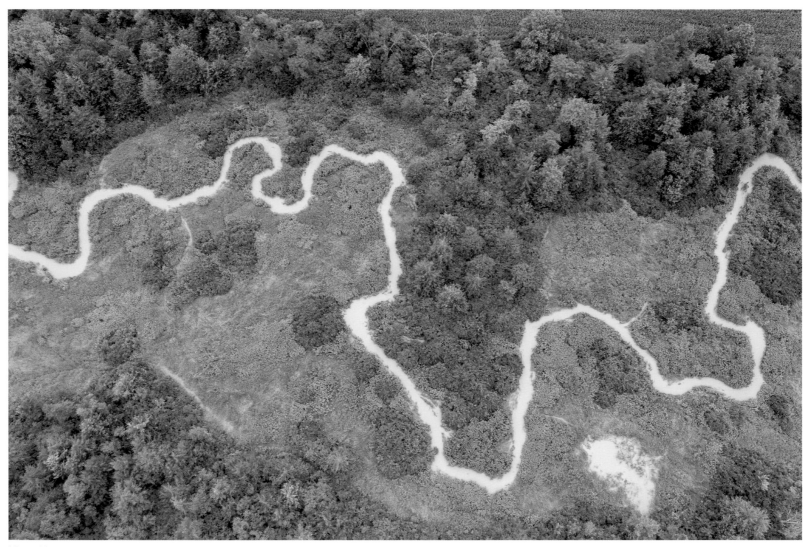

New Haven

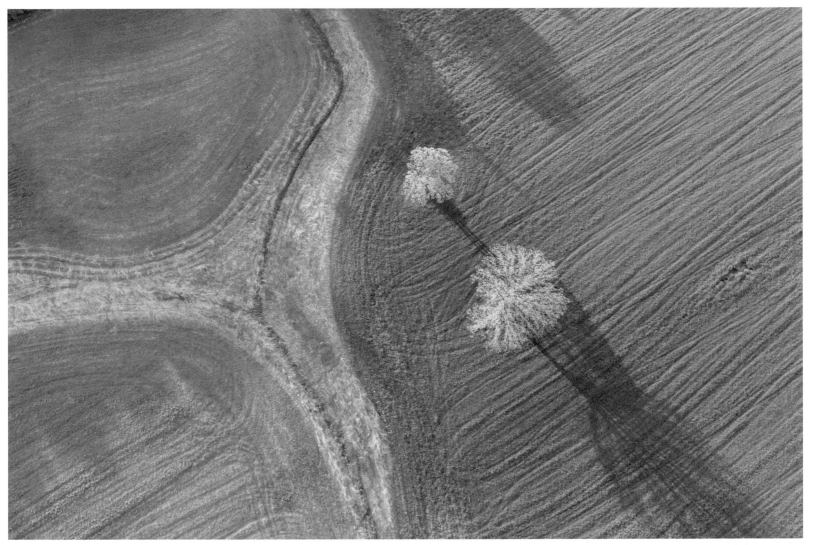

WEYBRIDGE

WHITING

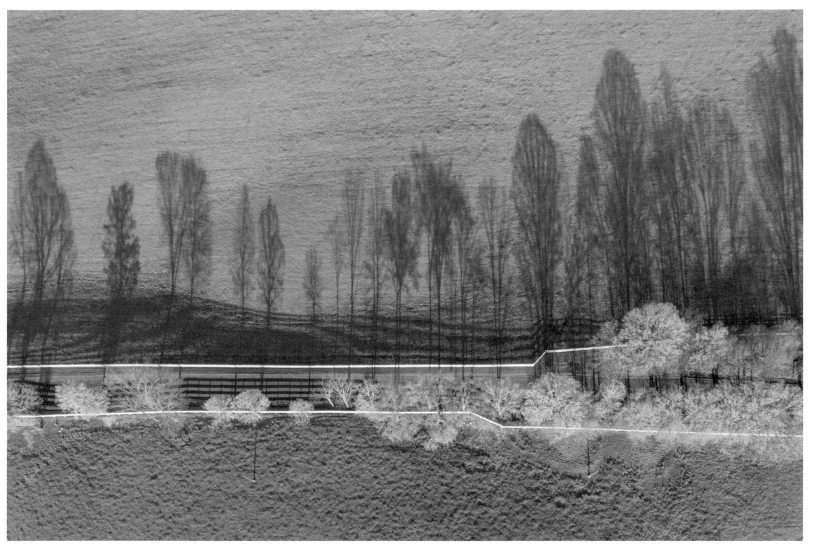

SHOREHAM

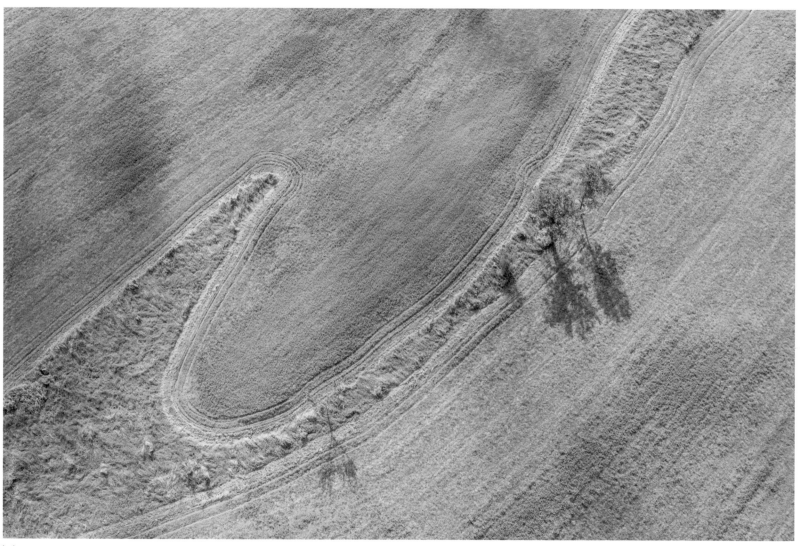

WHITING

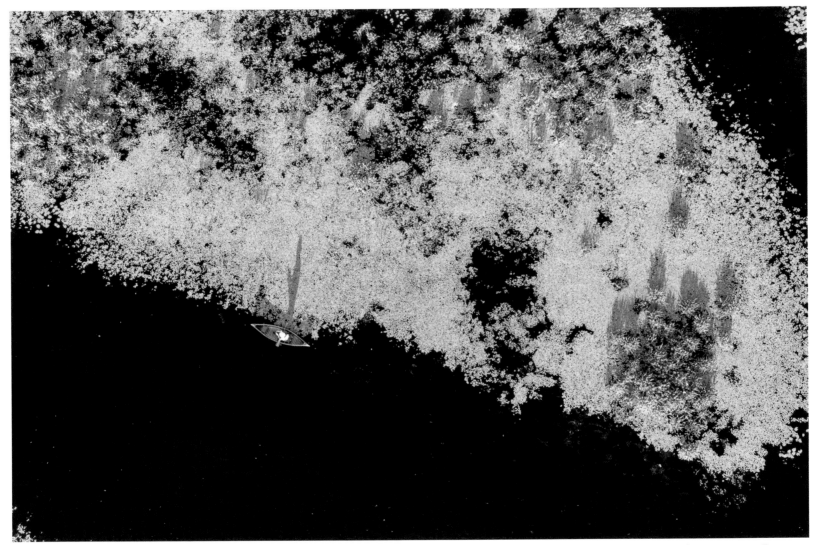

BRISTOL

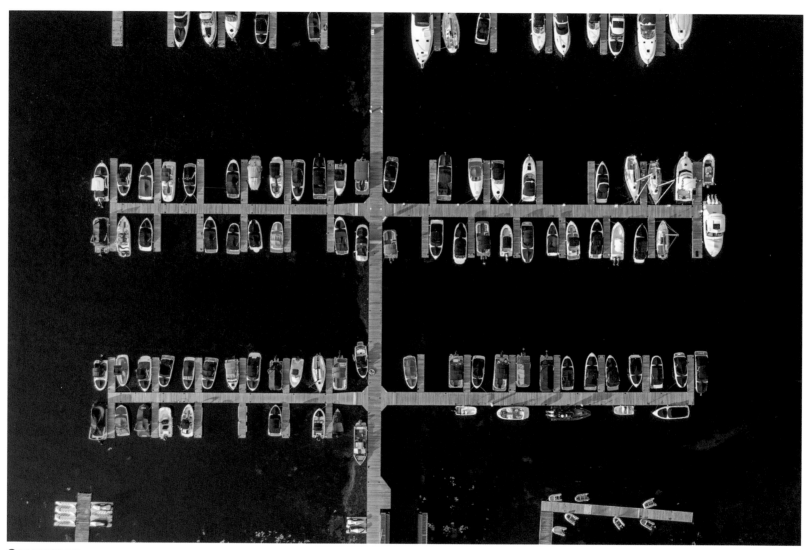

COLCHESTER

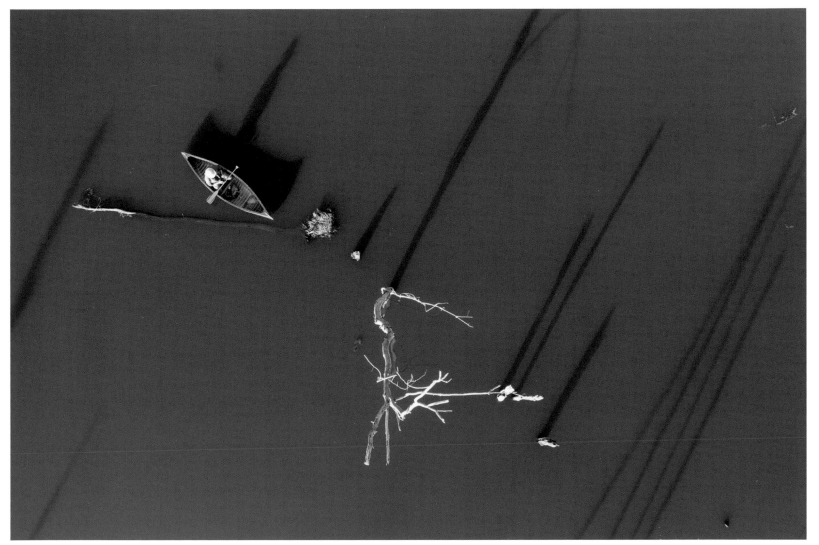

BRANDON

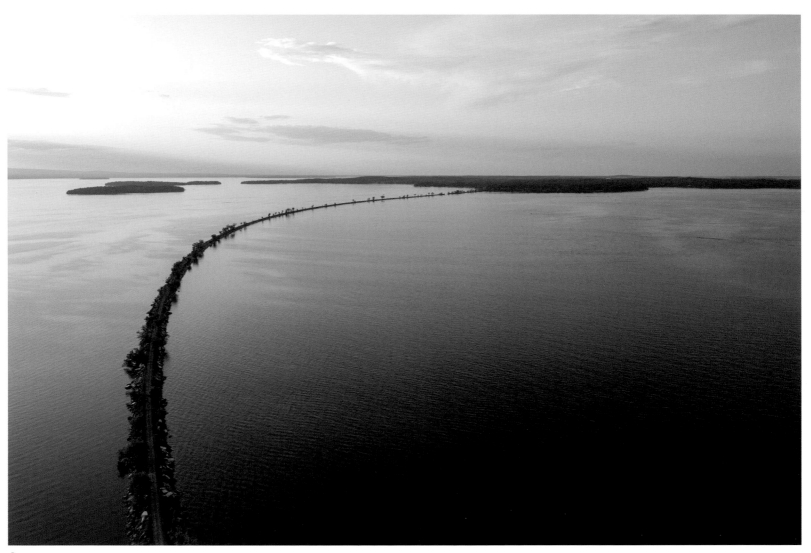

COLCHESTER

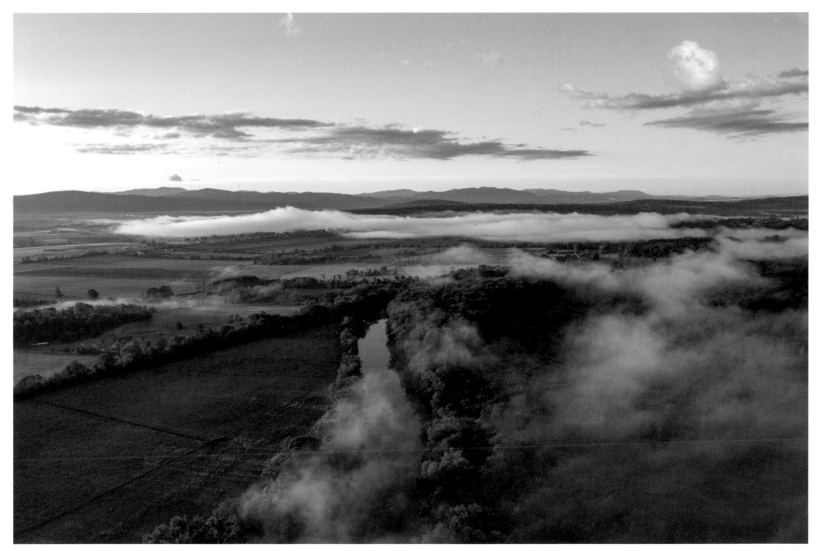

WEYBRIDGE

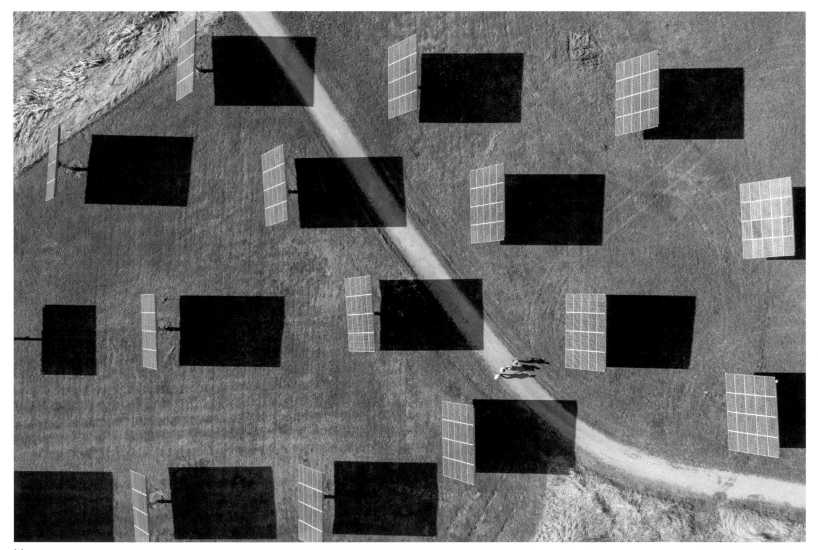

MIDDLEBURY

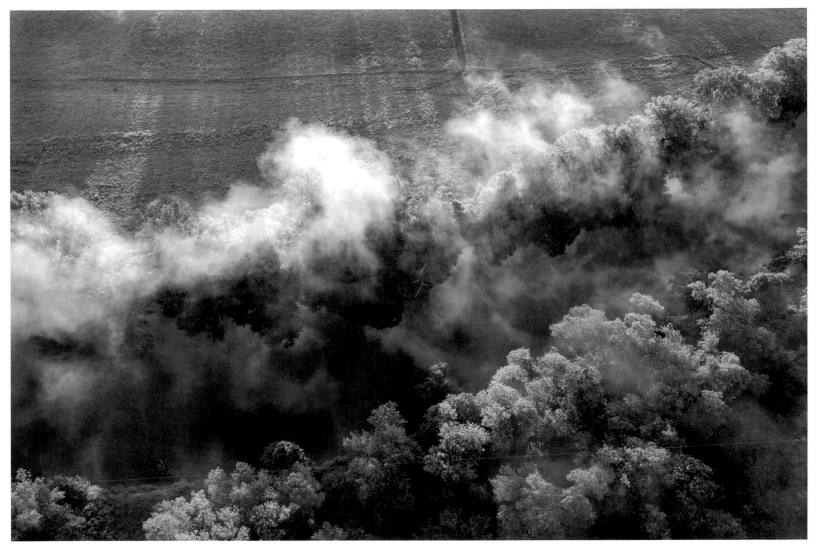

WEYBRIDGE

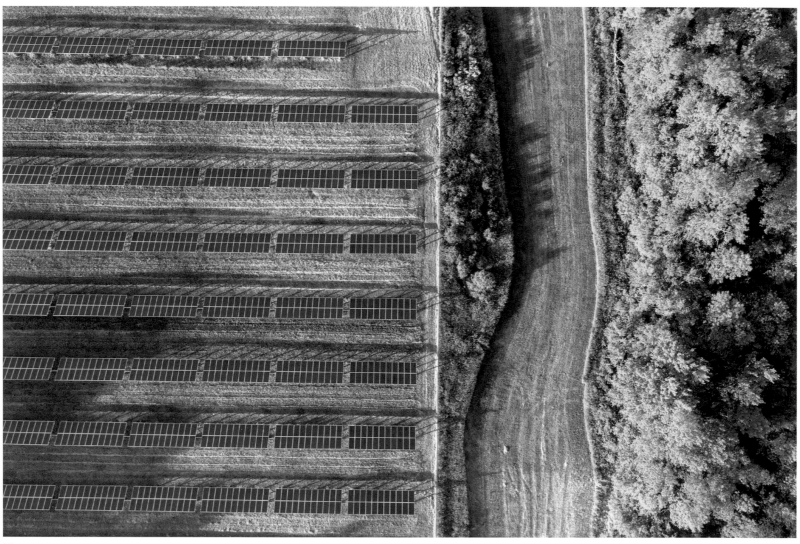

MIDDLEBURY

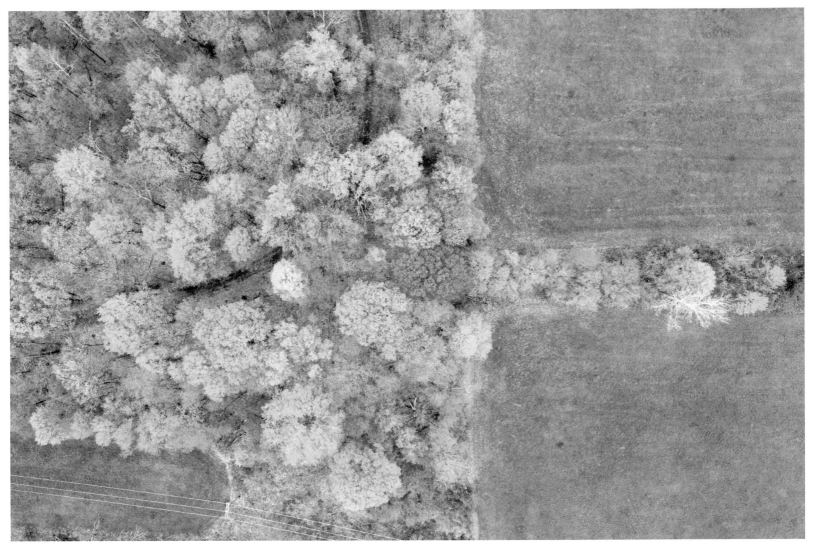

BRANDON

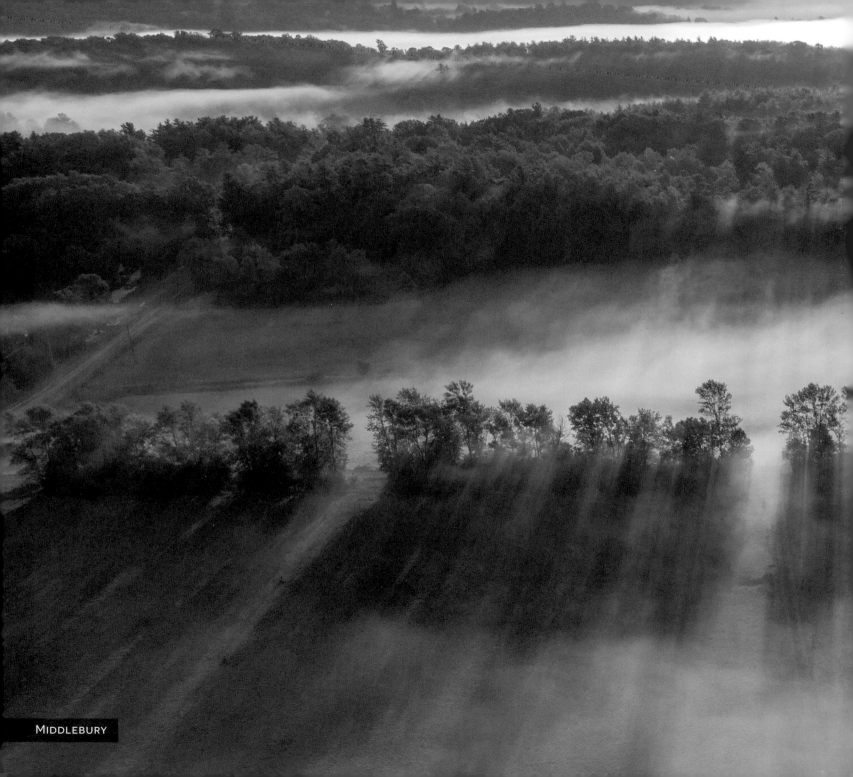

MIDDLEBURY

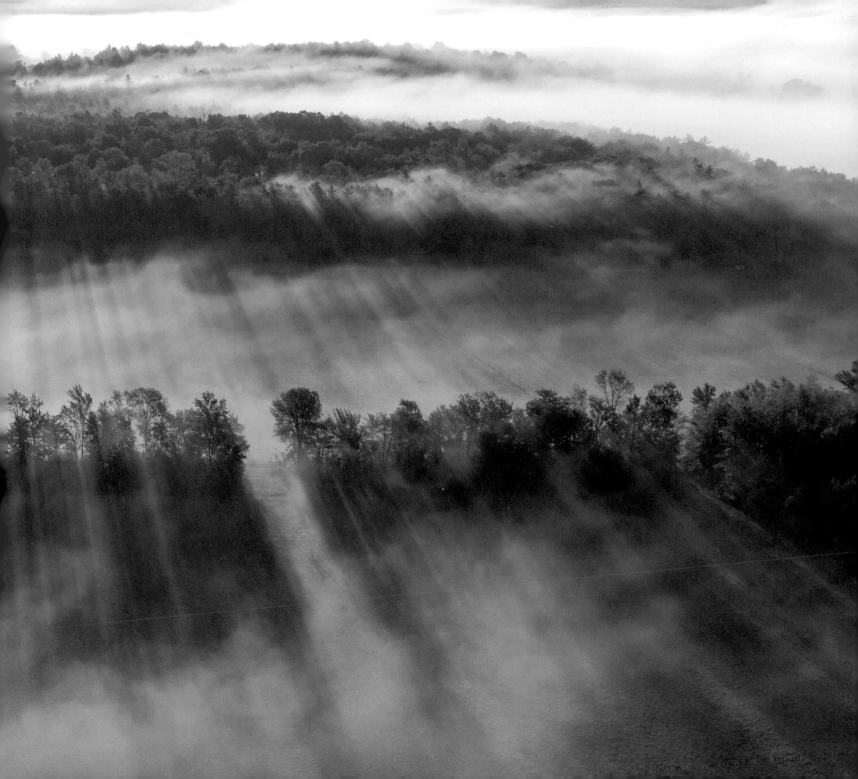

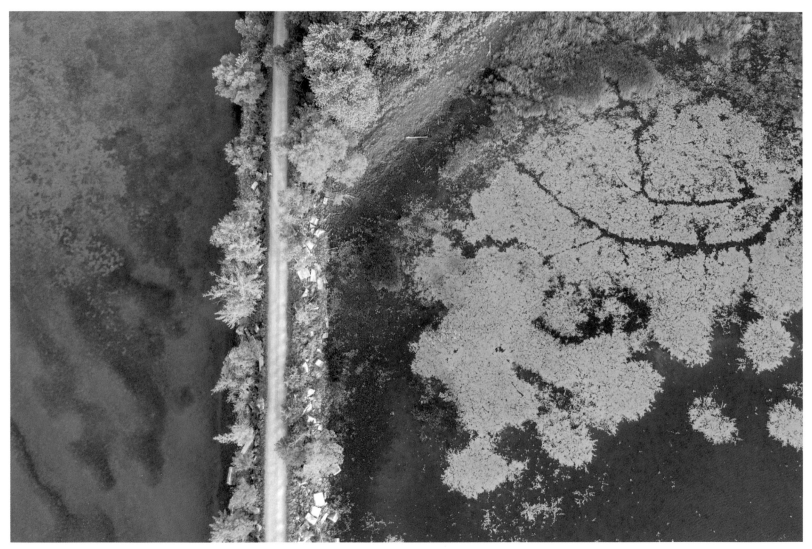

COLCHESTER

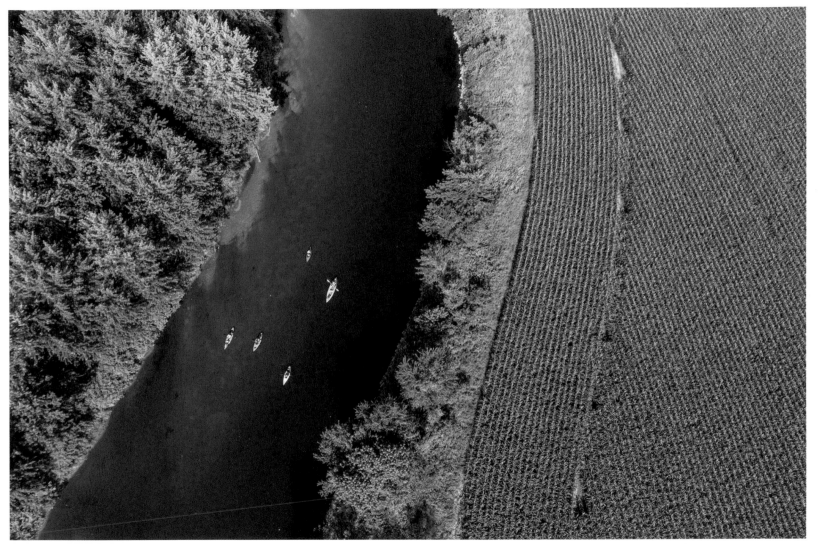

CAMBRIDGE

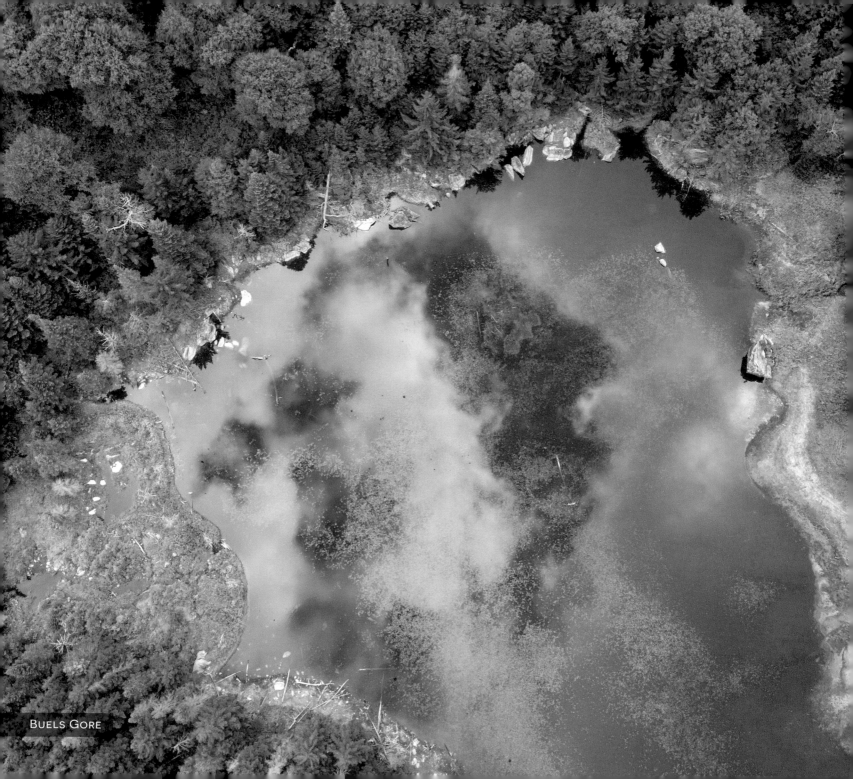

Buels Gore

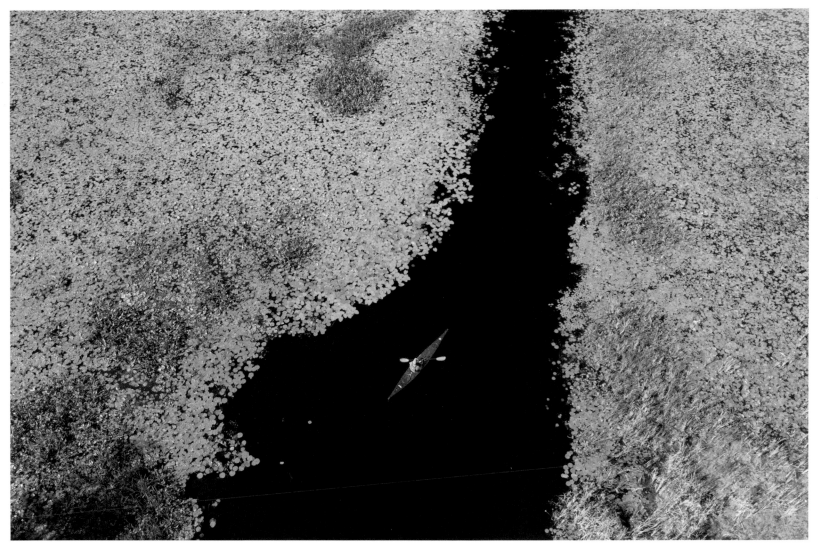

SUDBURY

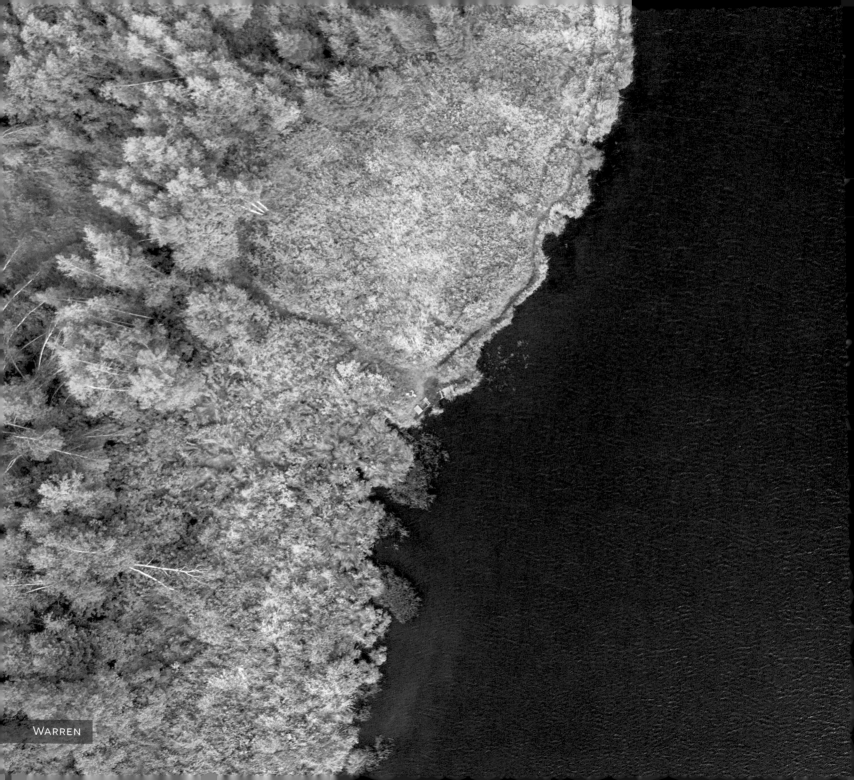

WARREN

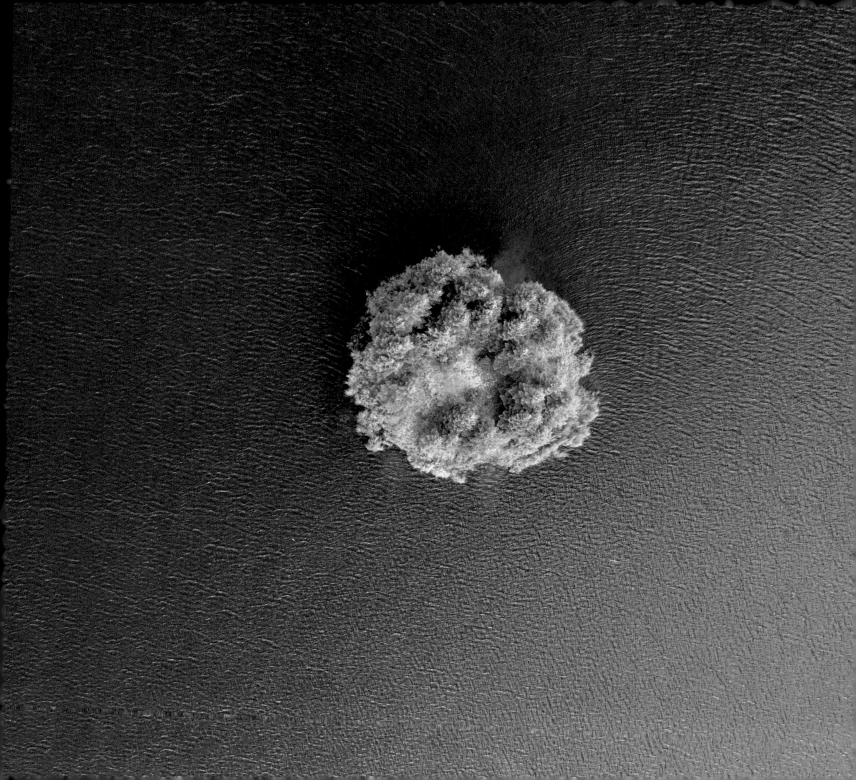

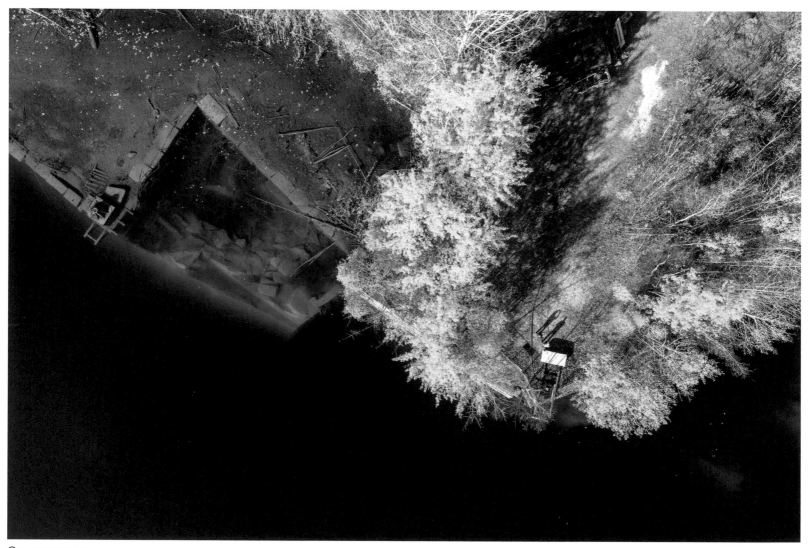

GRANITEVILLE

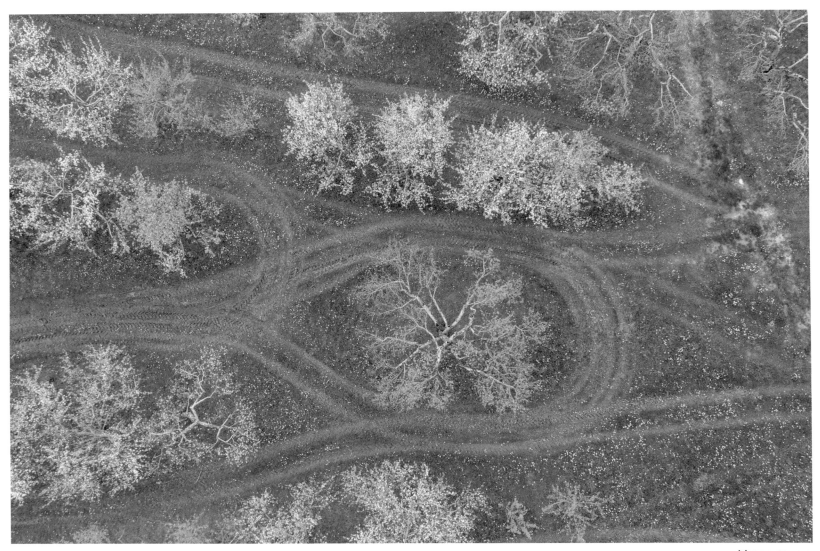

MIDDLEBURY

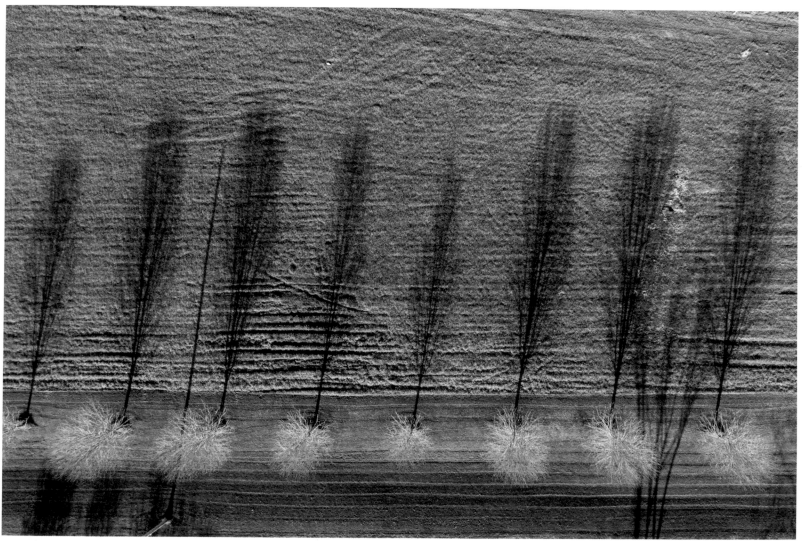

CHARLOTTE

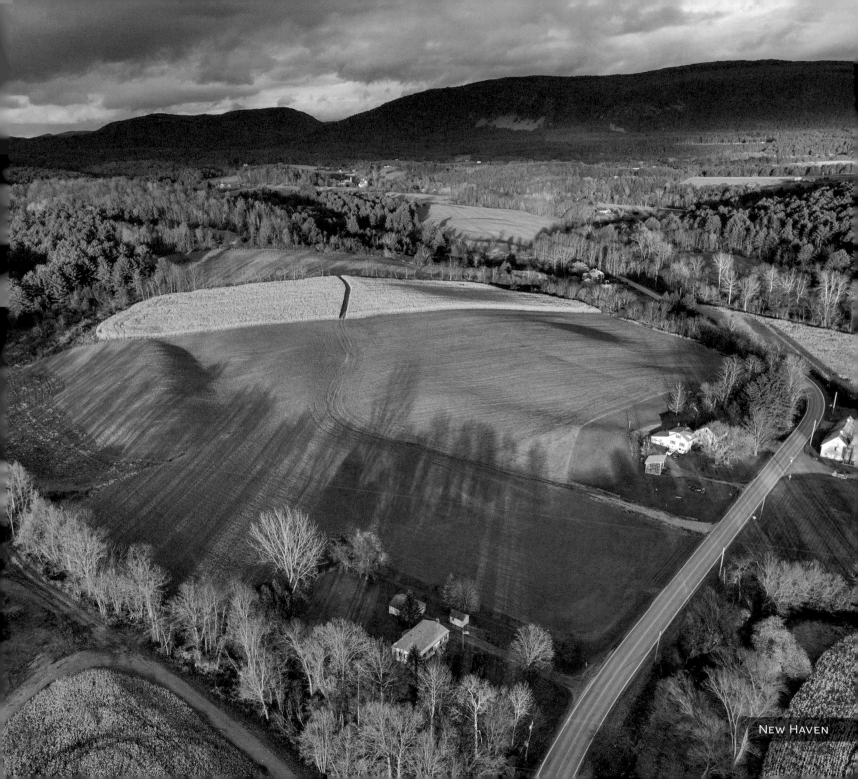

New Haven

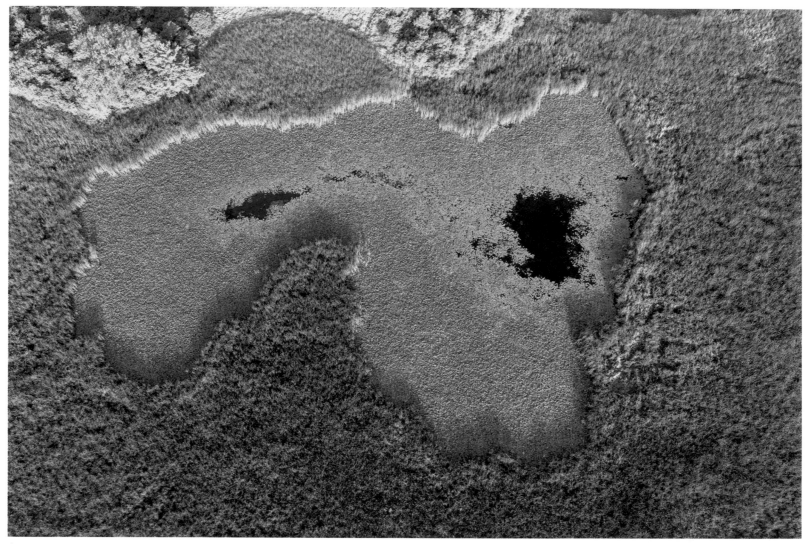

ADDISON

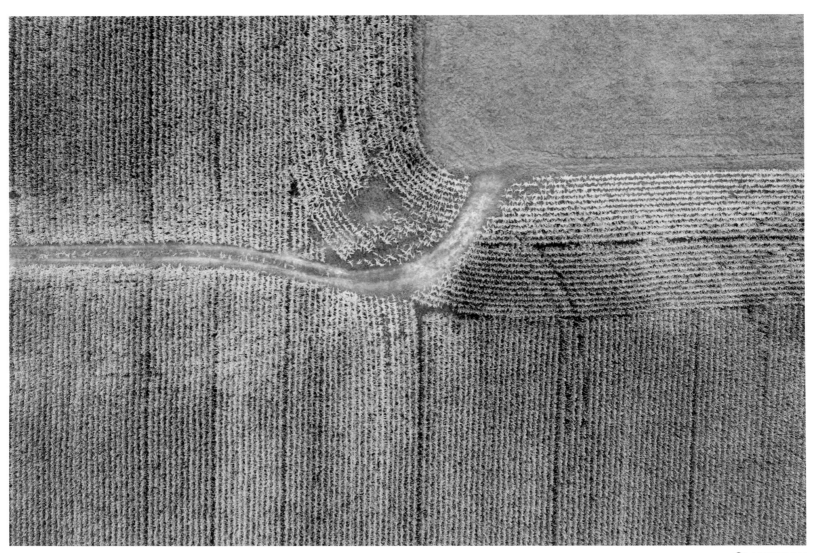

CLARENDON

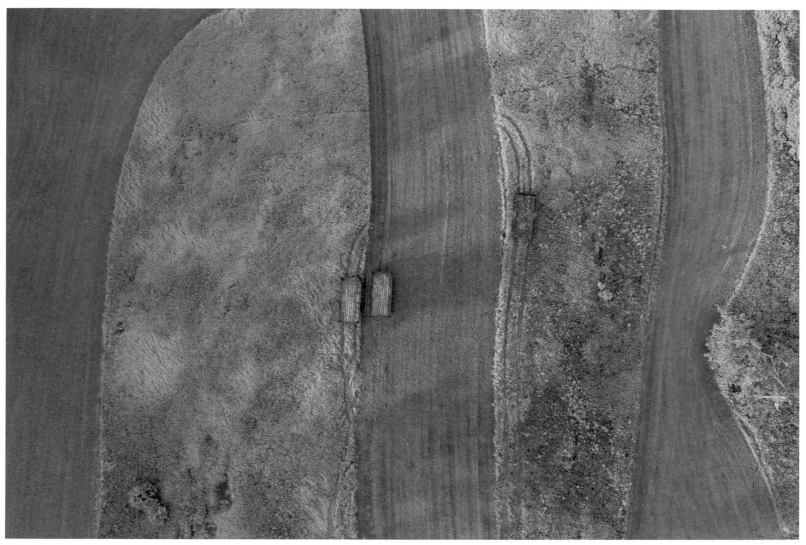

WEYBRIDGE

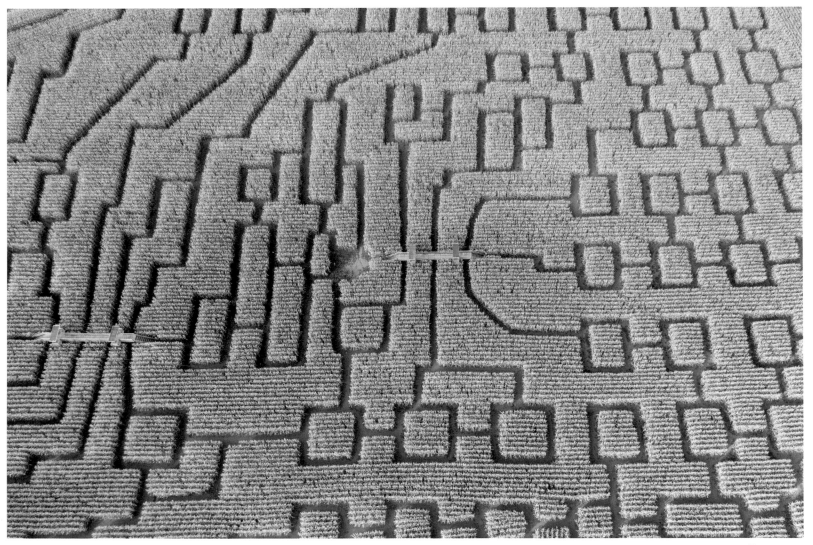

DANVILLE

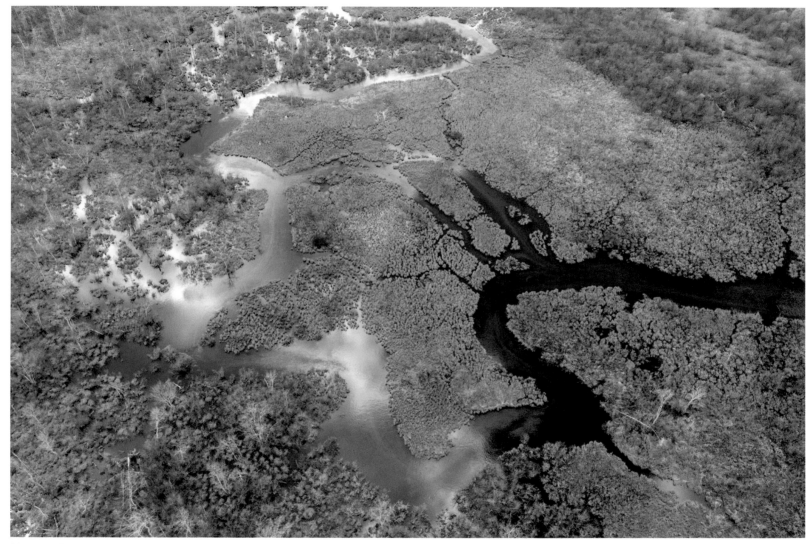

MOUNT TABOR

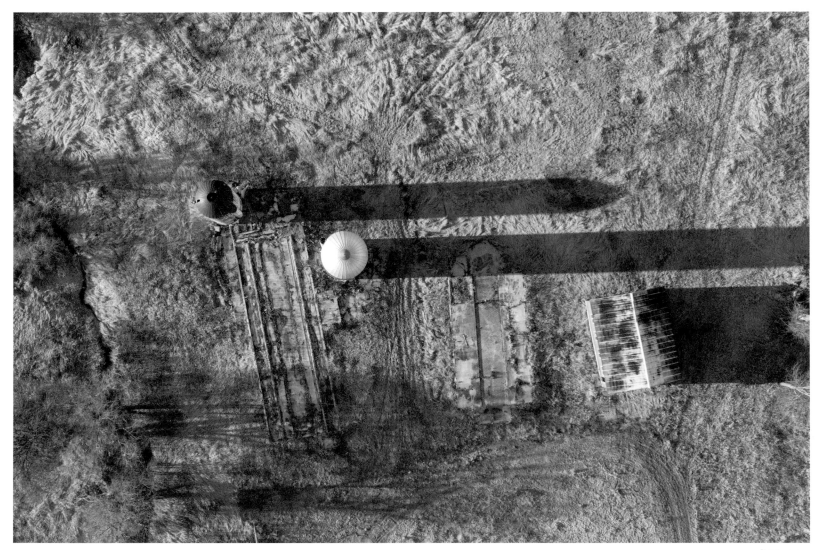

ADDISON

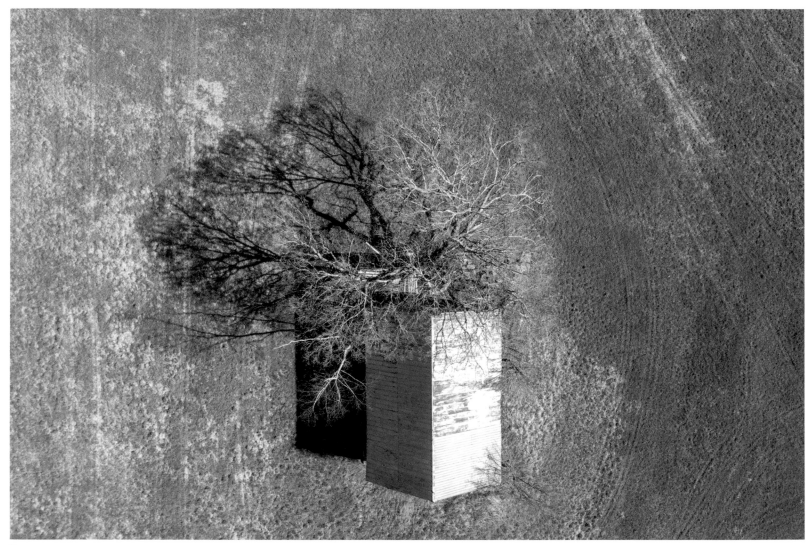

Bethel

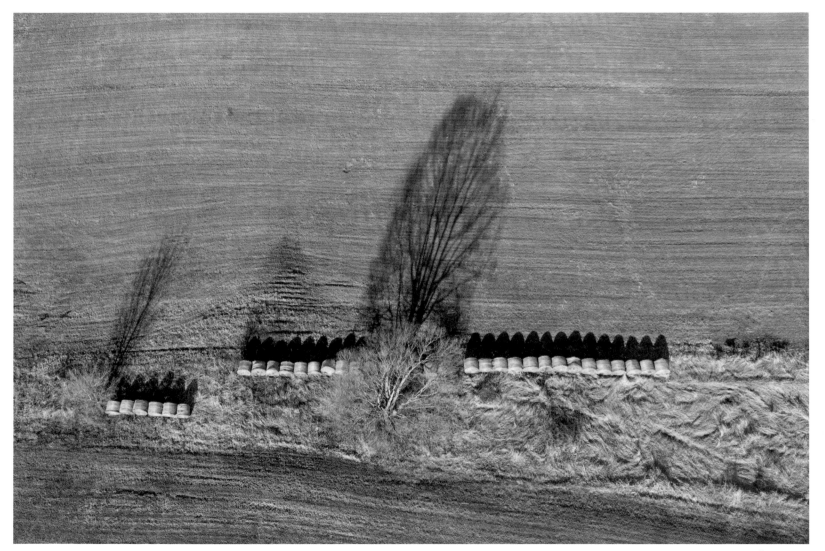

ADDISON

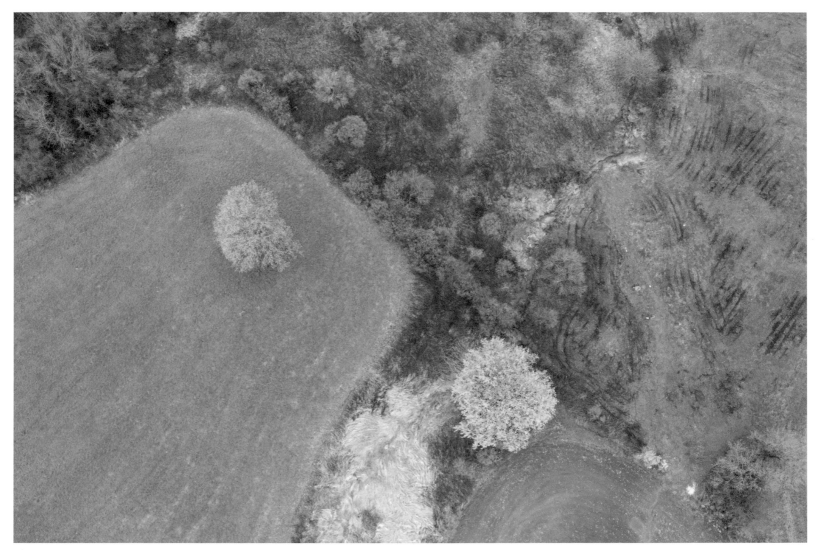

MIDDLEBURY

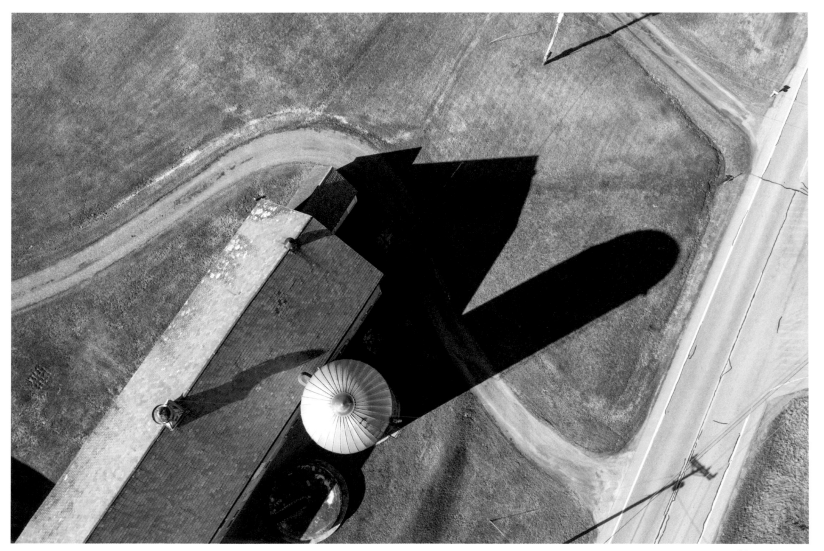

New Haven

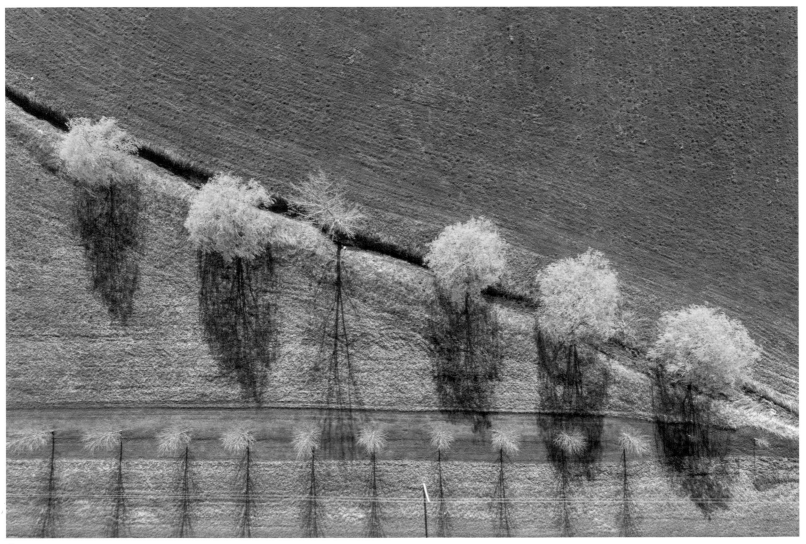

CHARLOTTE

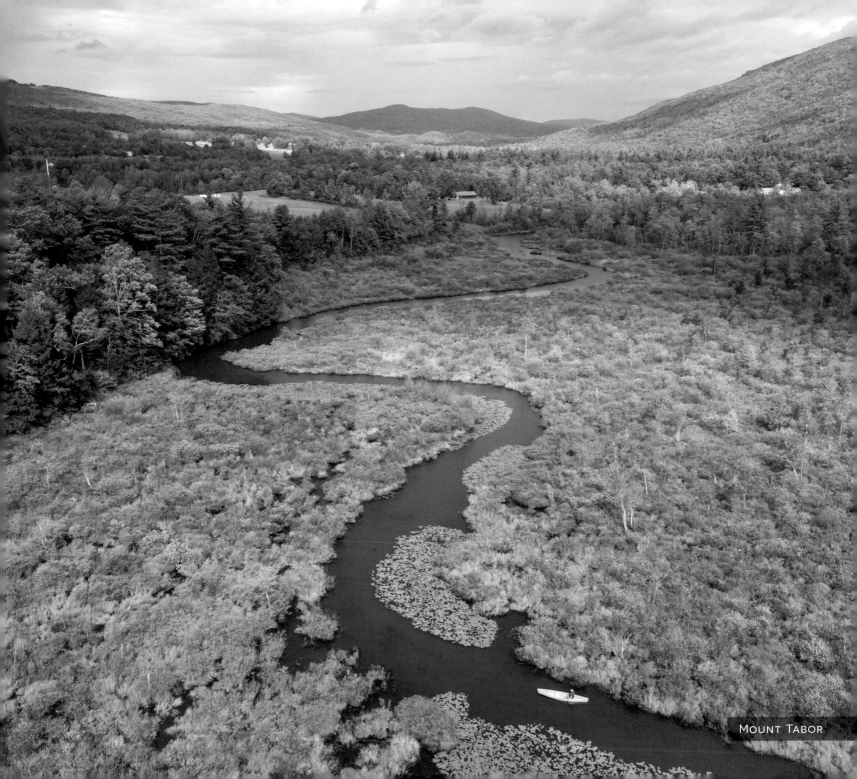

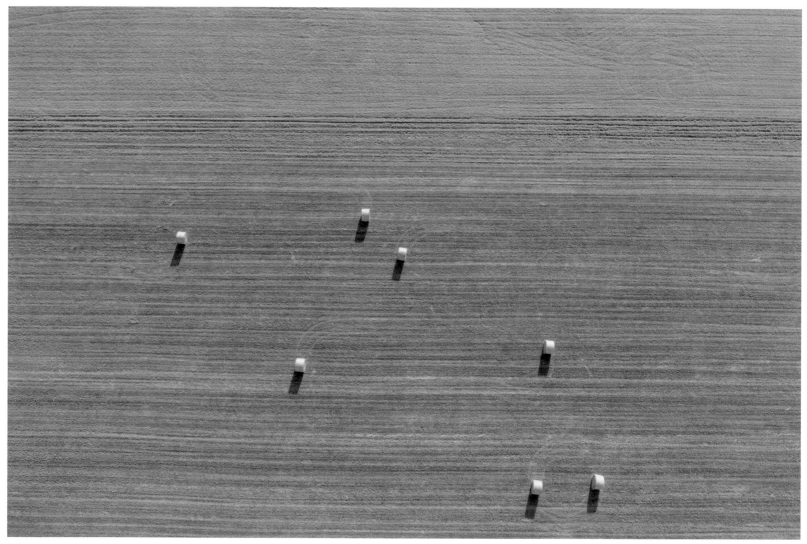

Whiting

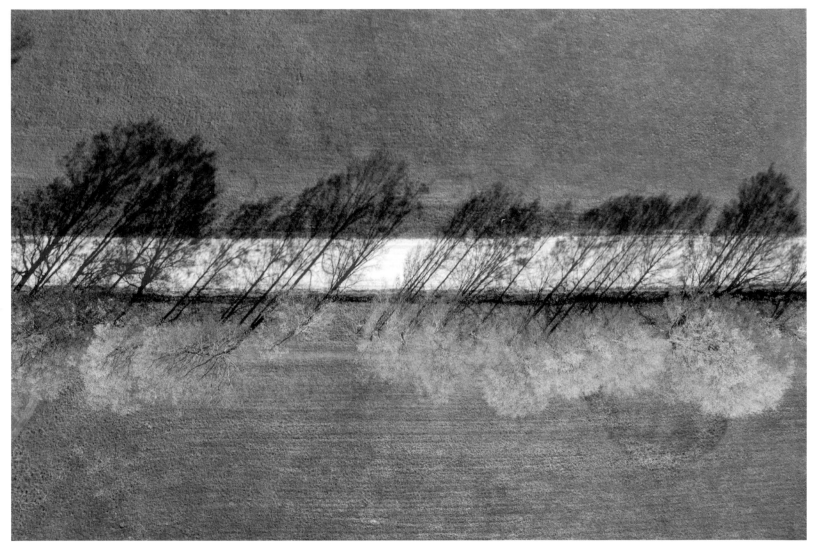

SUDBURY

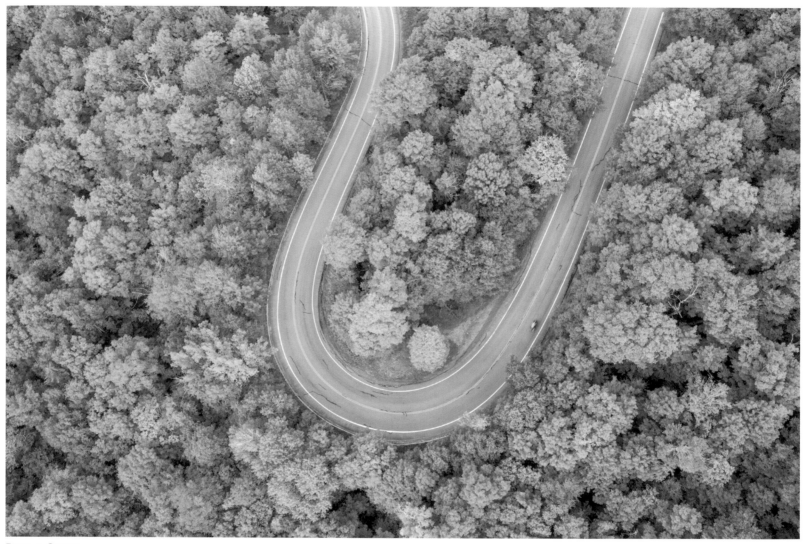

BUELS GORE

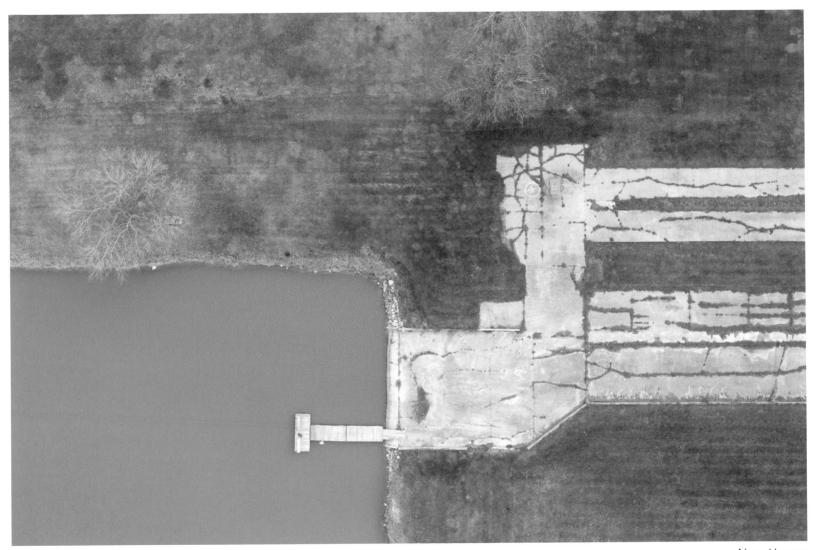

NEW HAVEN

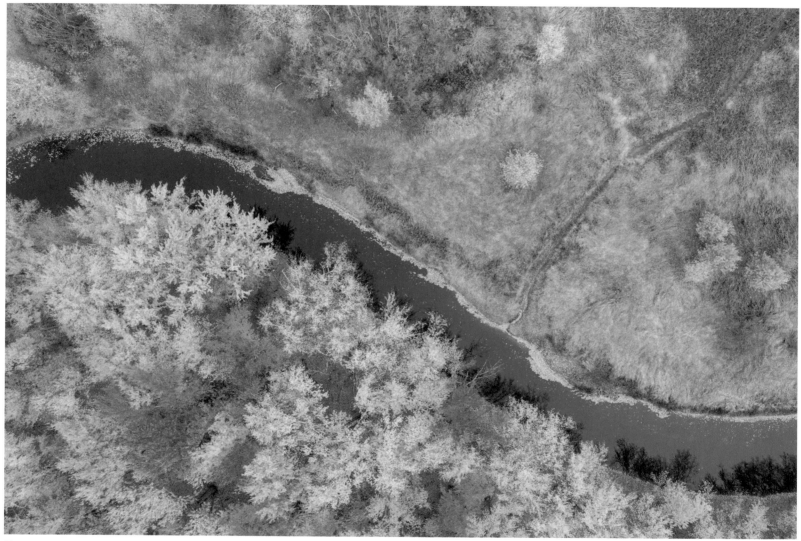

FERRISBURGH

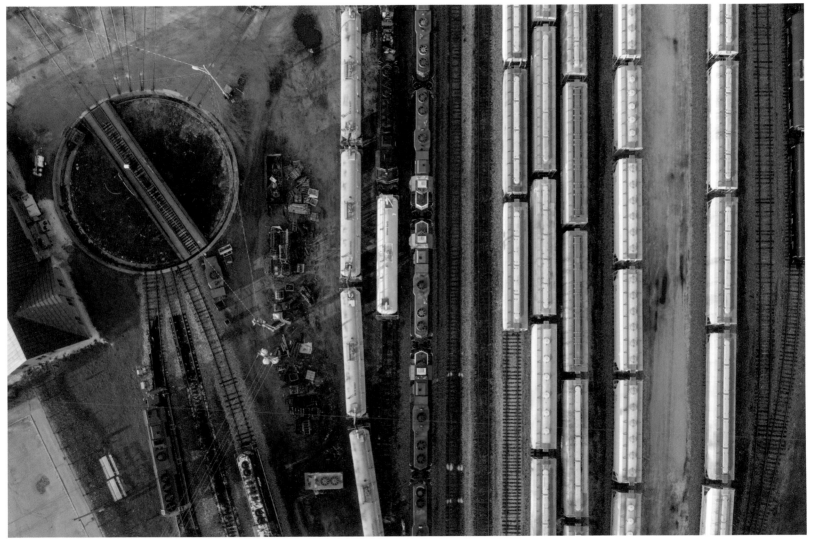

BURLINGTON

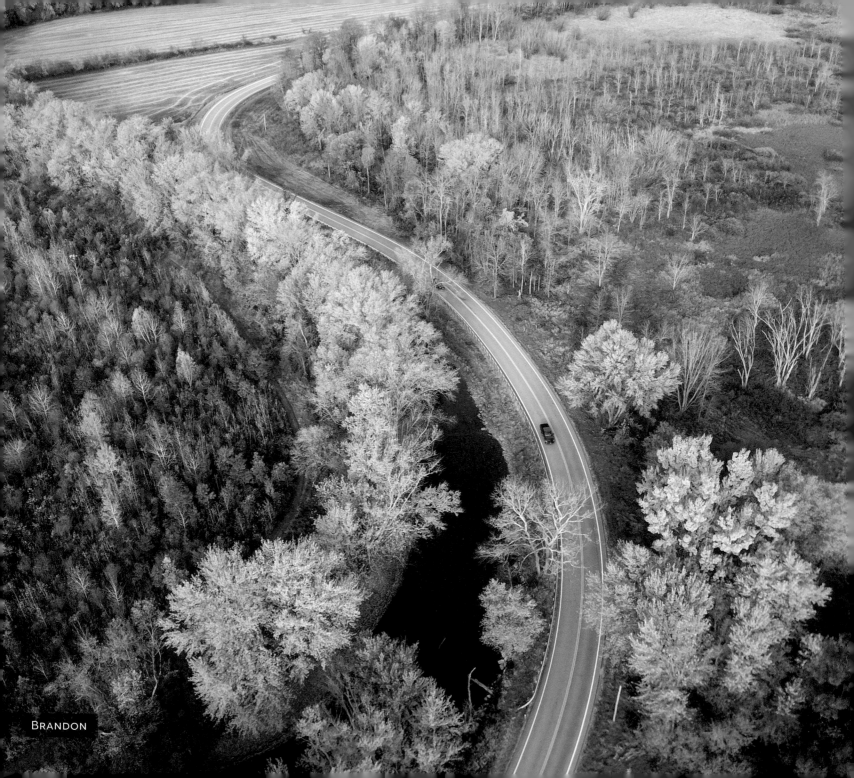

BRANDON

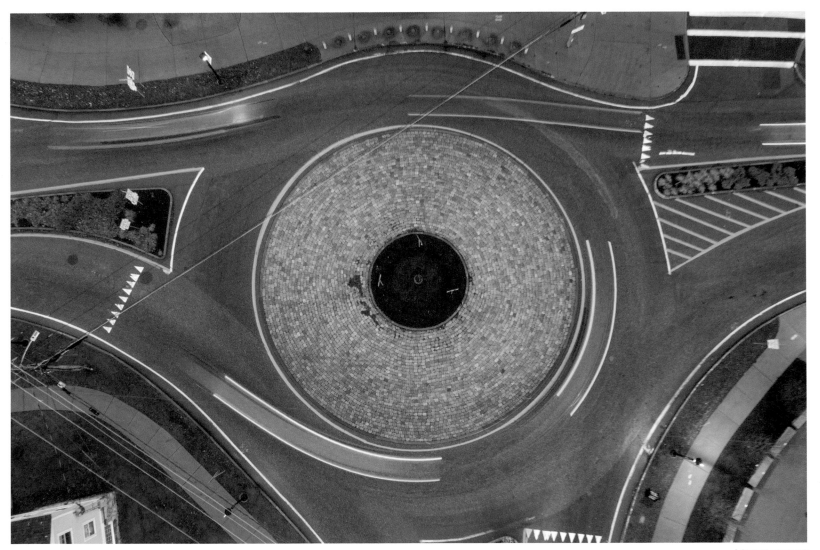

MIDDLEBURY

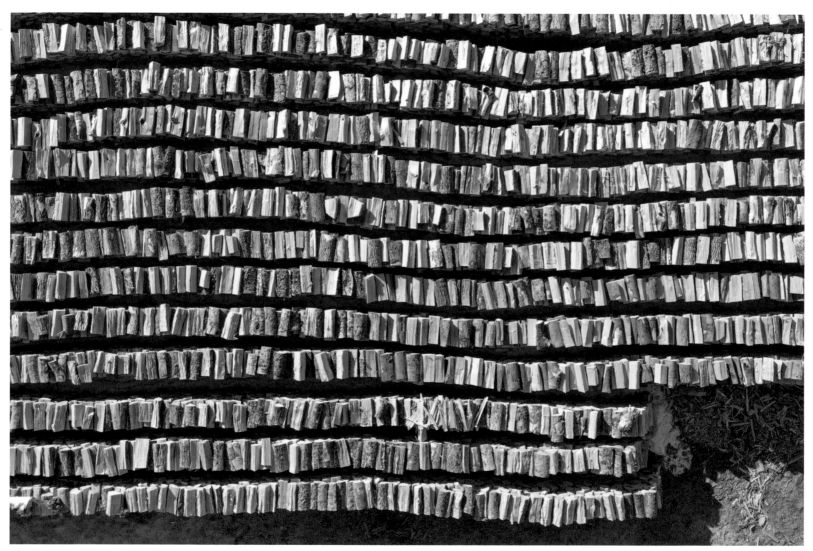

MONKTON

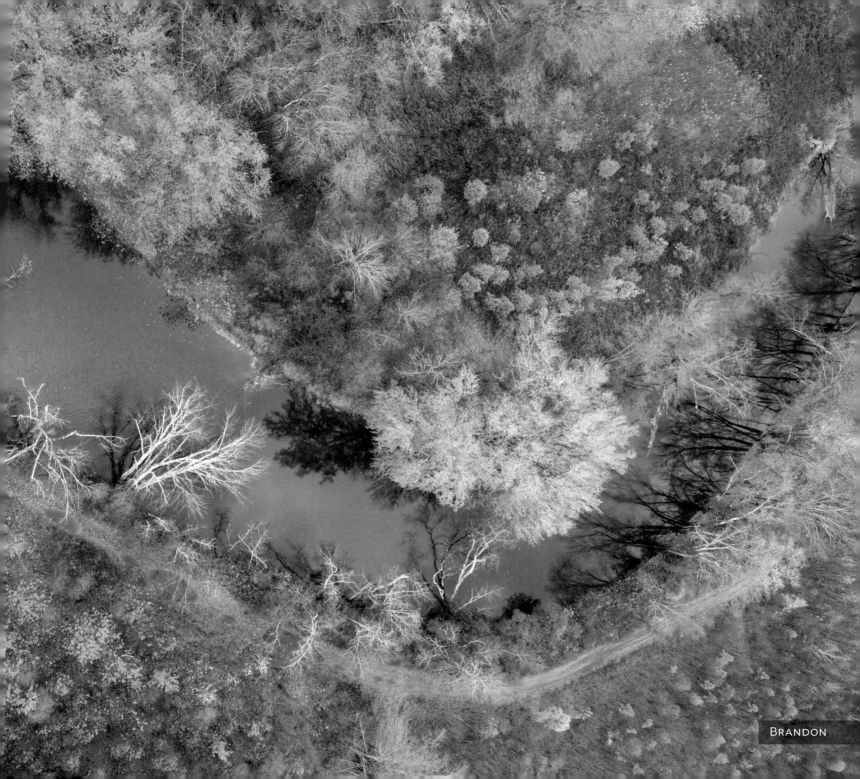

BRANDON

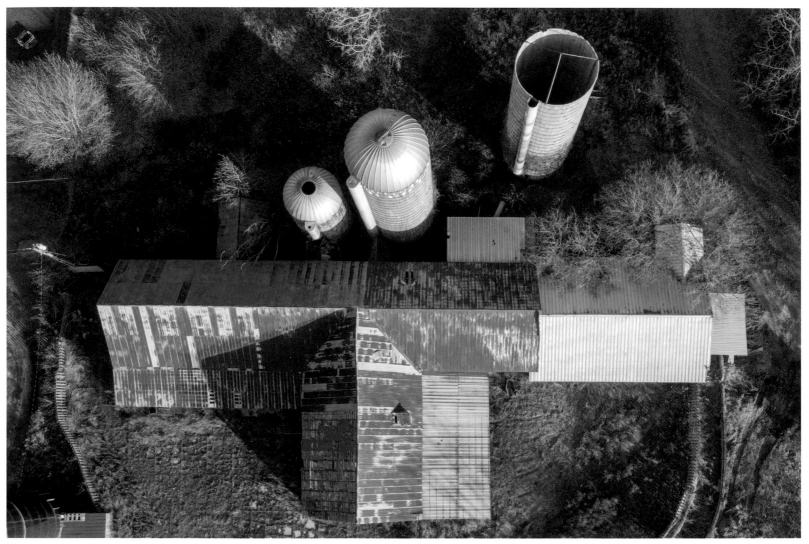

MIDDLEBURY

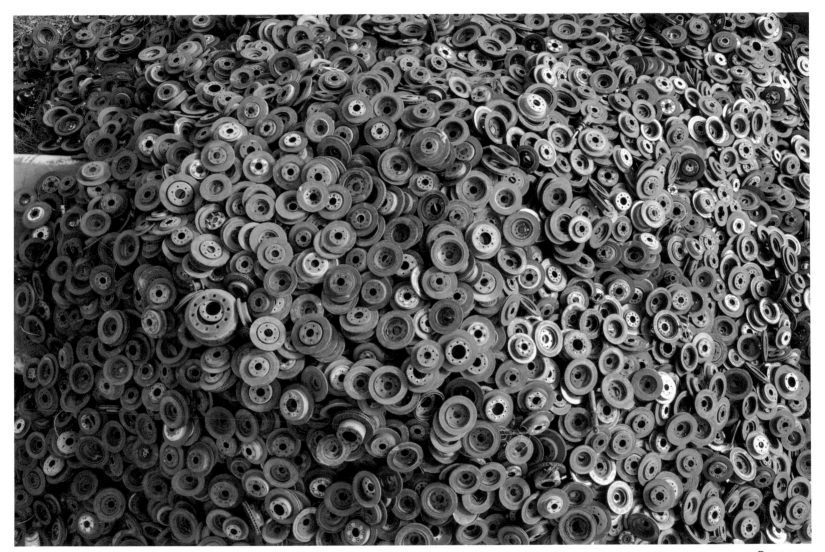

Rutland

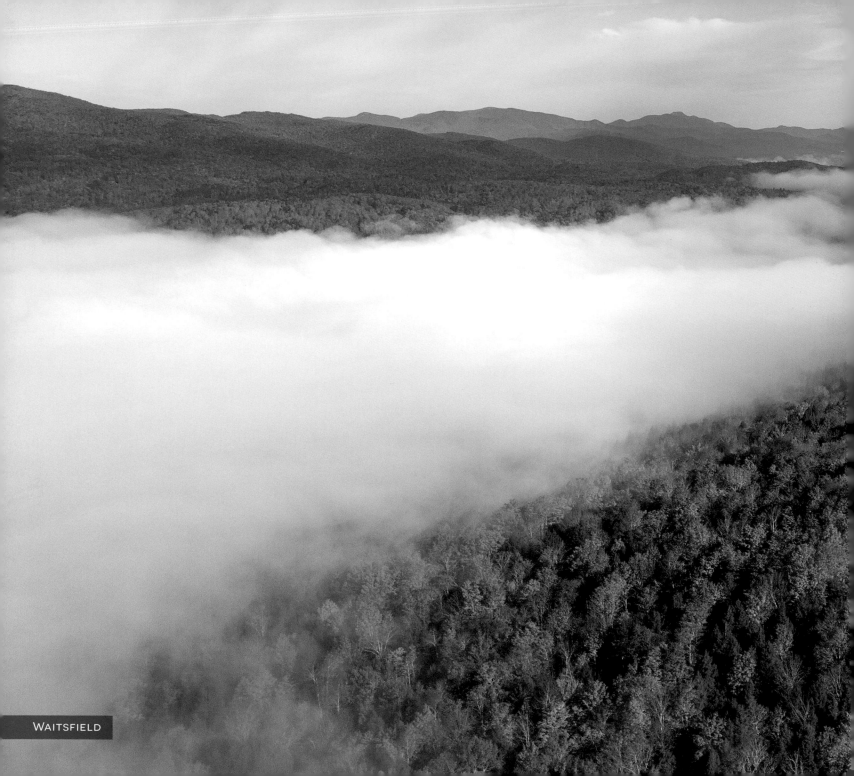

WAITSFIELD

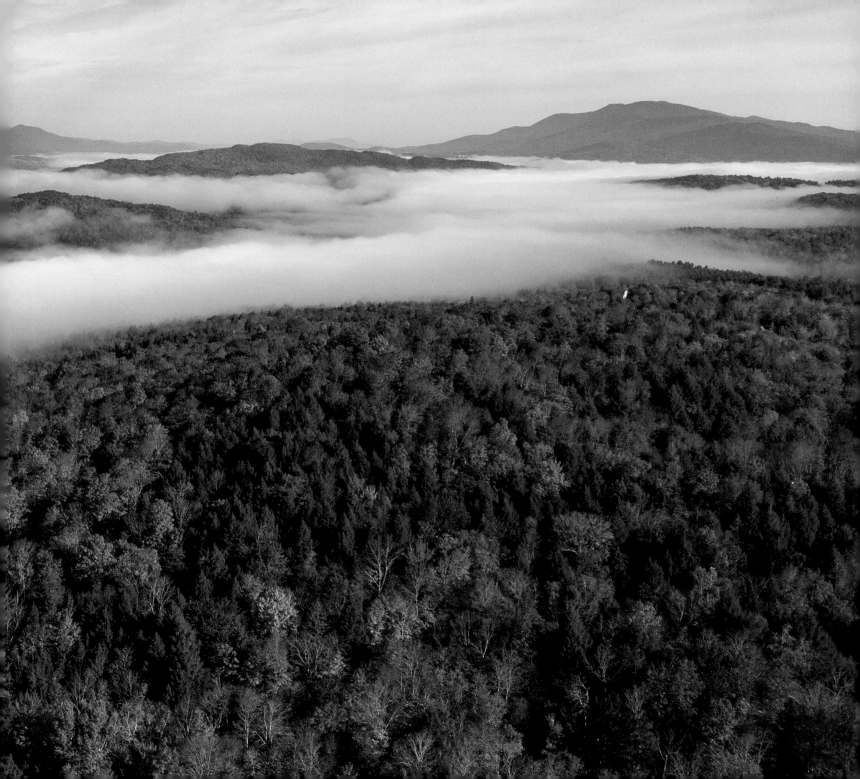

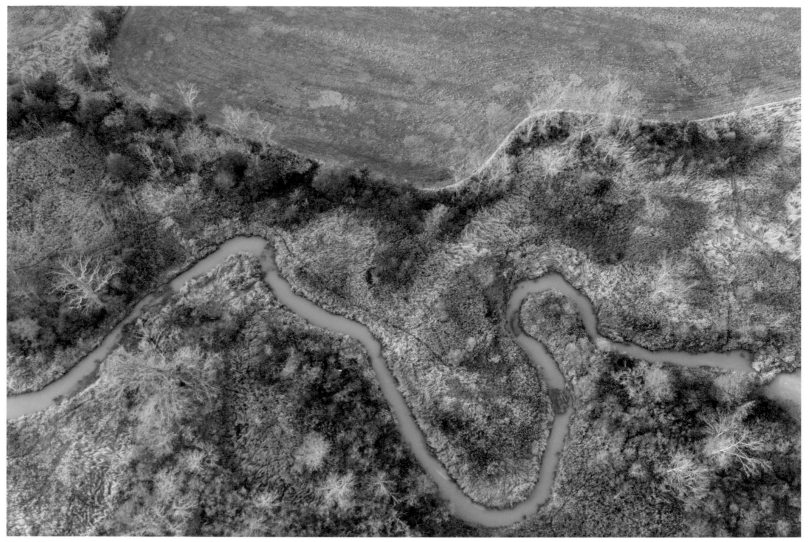

New Haven

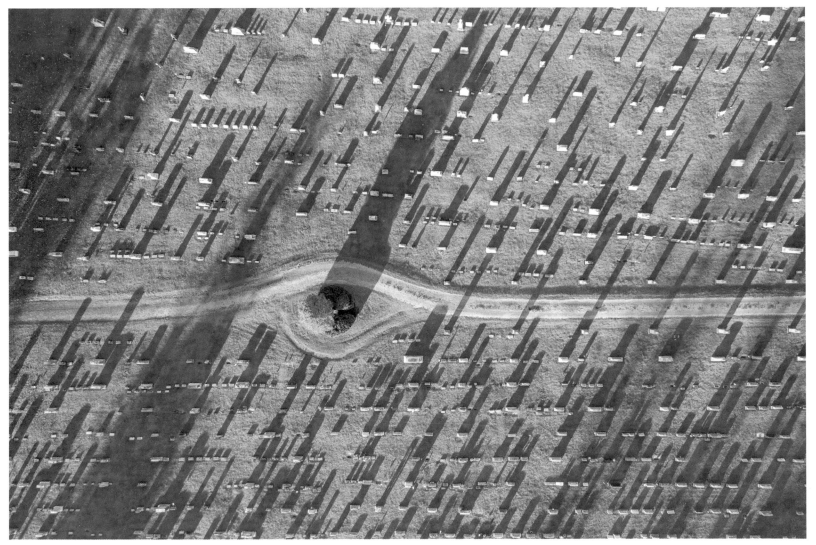

MIDDLEBURY

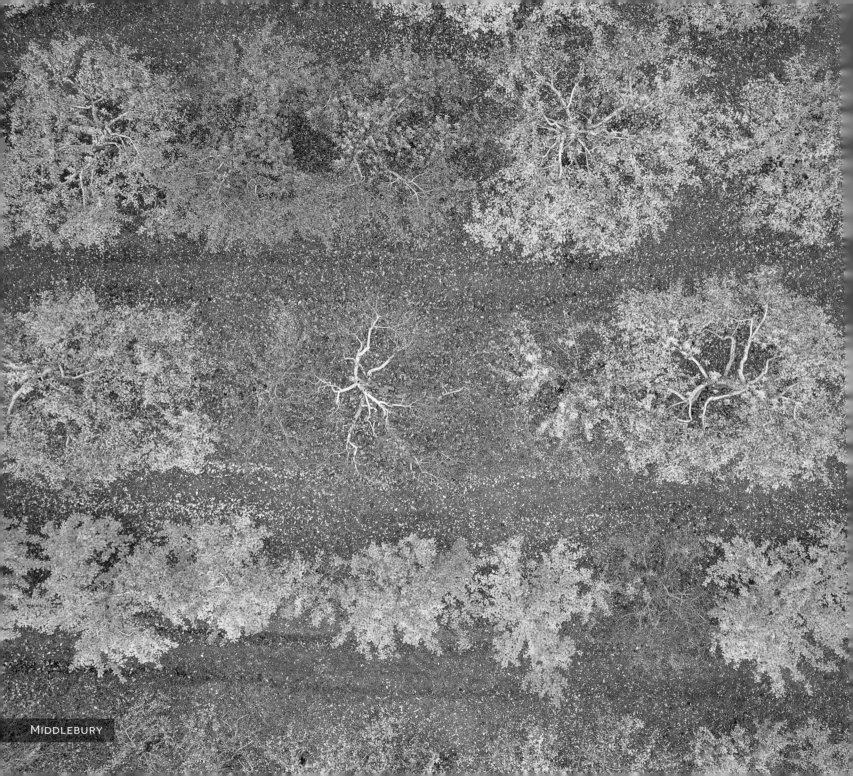

Middlebury

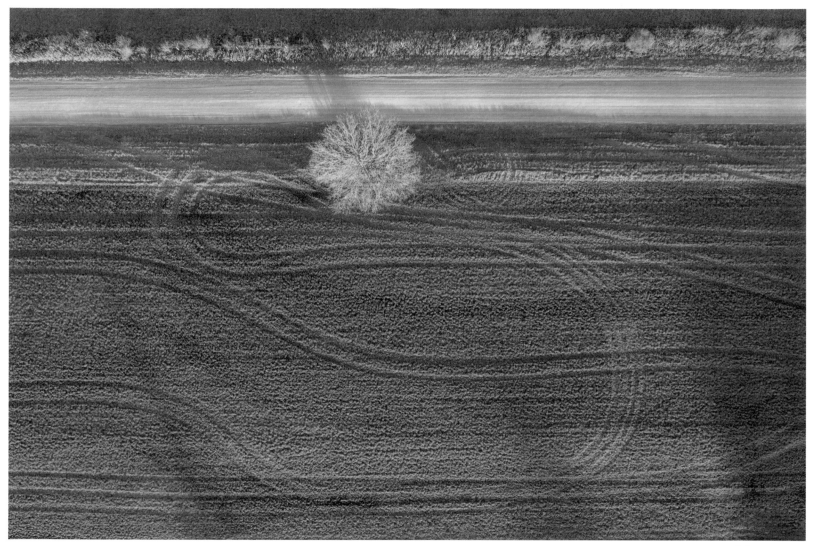

WEYBRIDGE

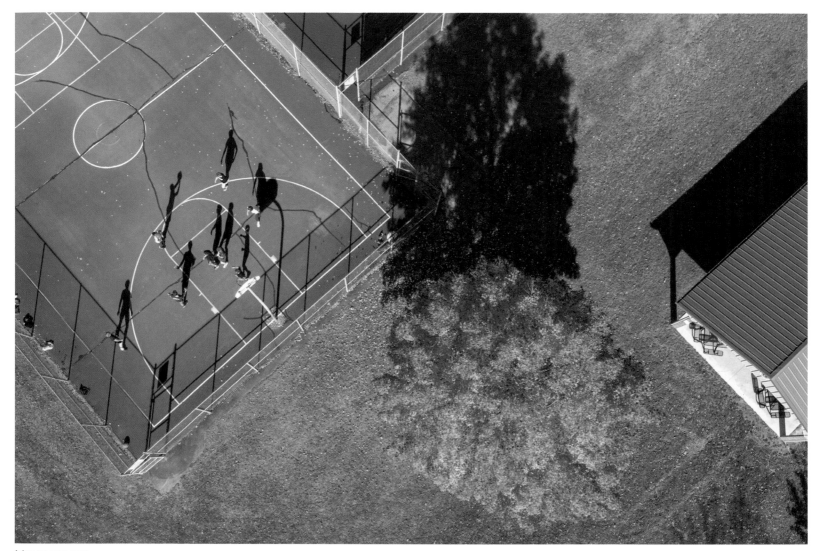

MIDDLEBURY

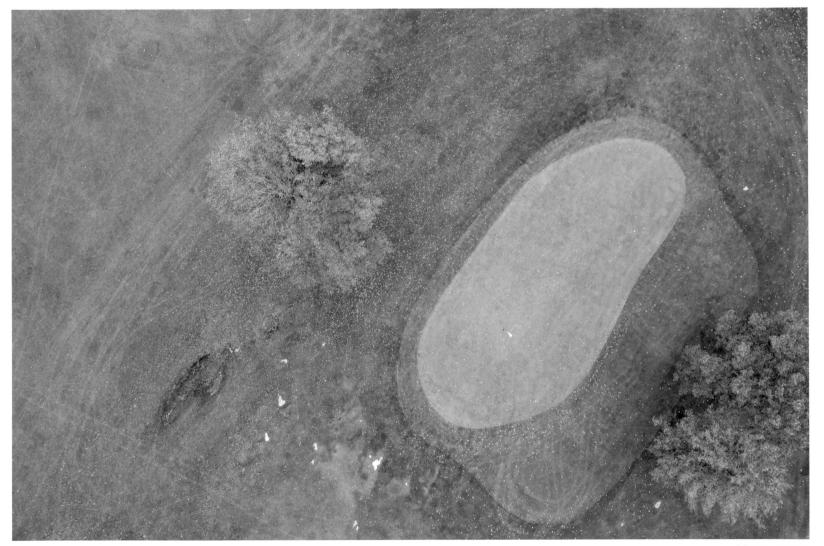

MIDDLEBURY

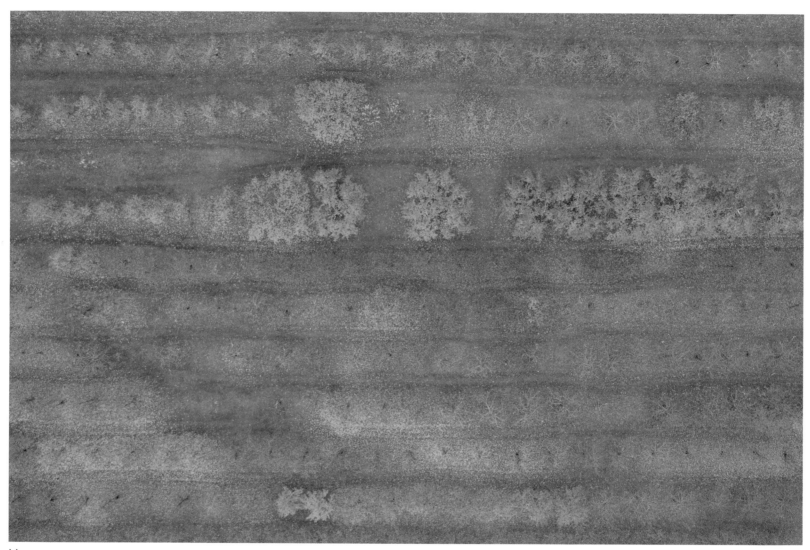

Middlebury

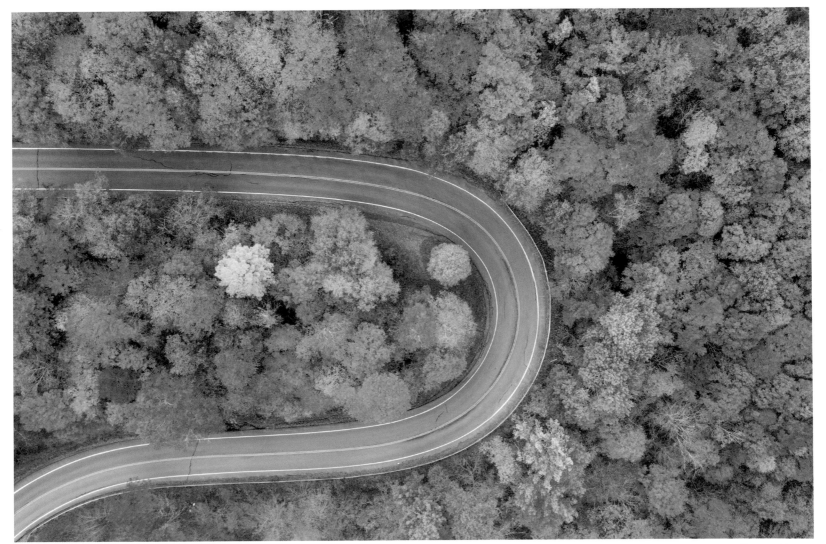

BUELS GORE

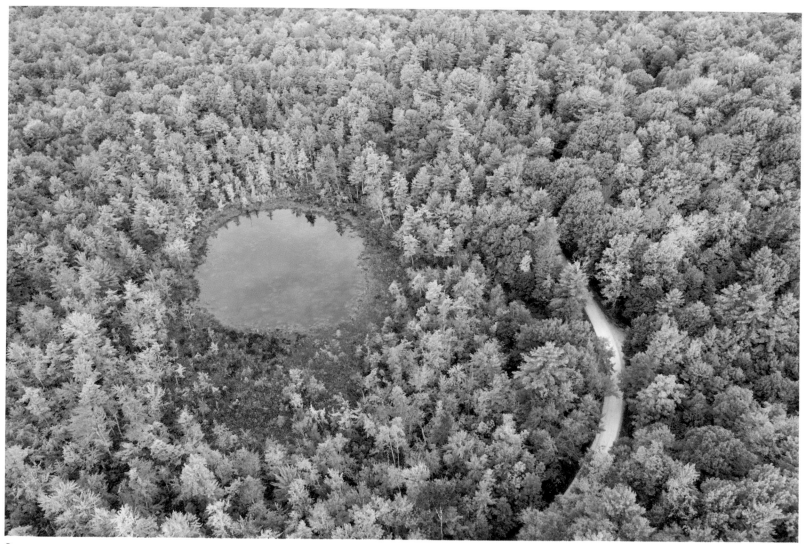

SUDBURY

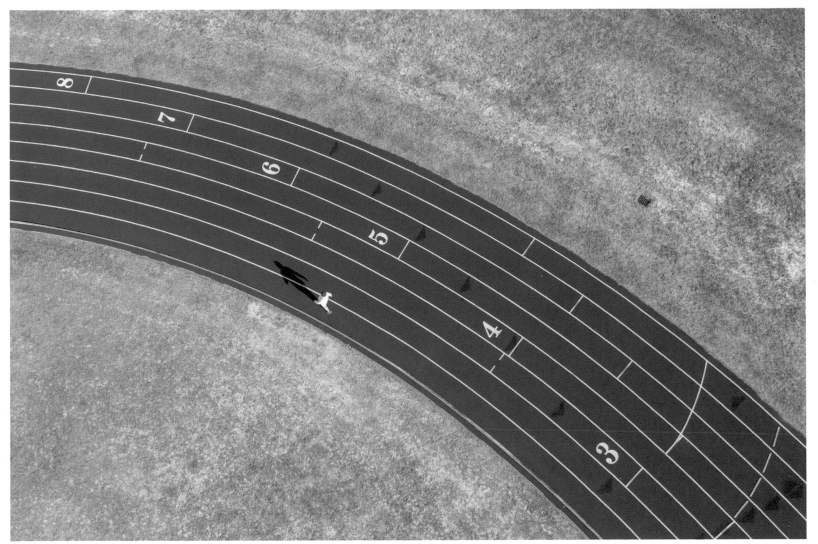

MIDDLEBURY

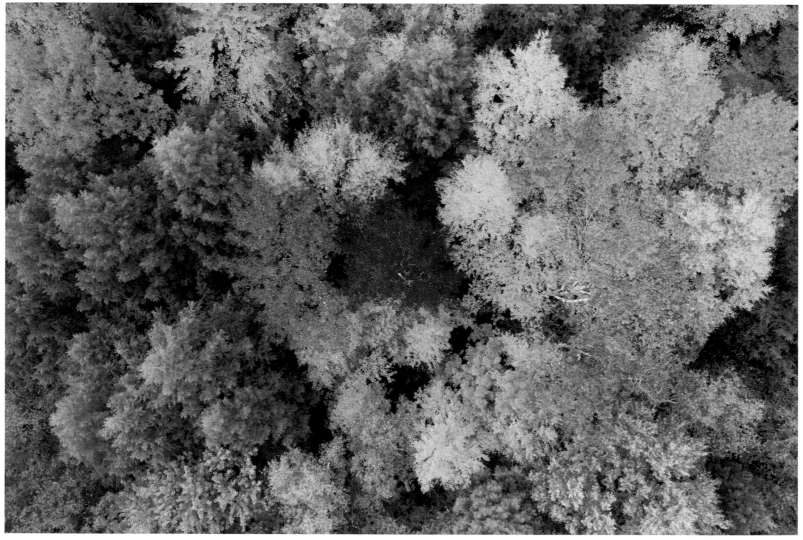

BRANDON

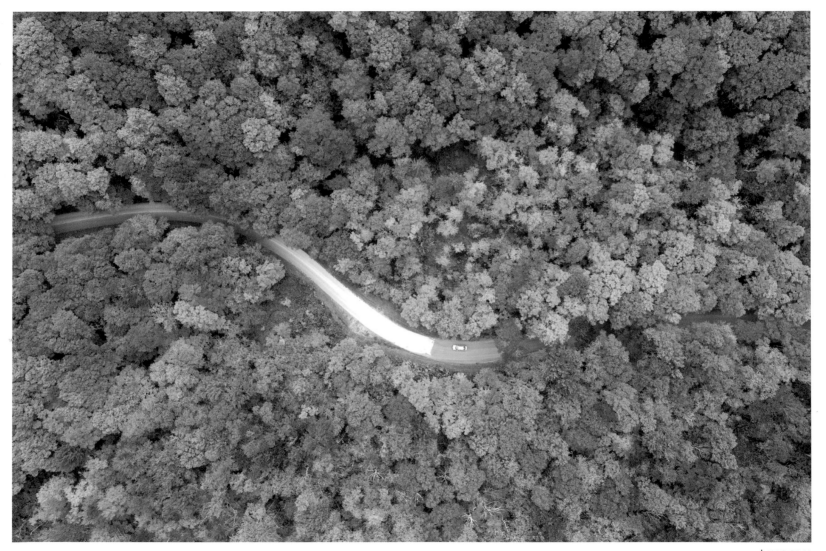

LINCOLN

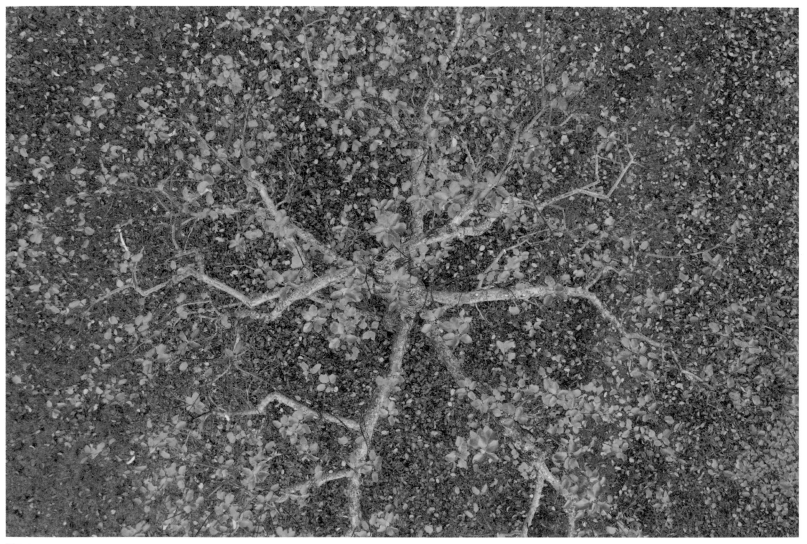

MIDDLEBURY

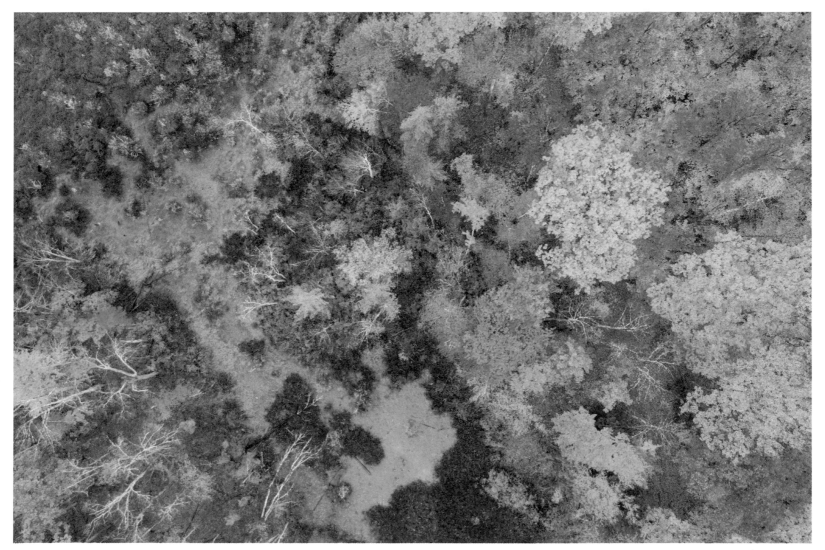

Leicester

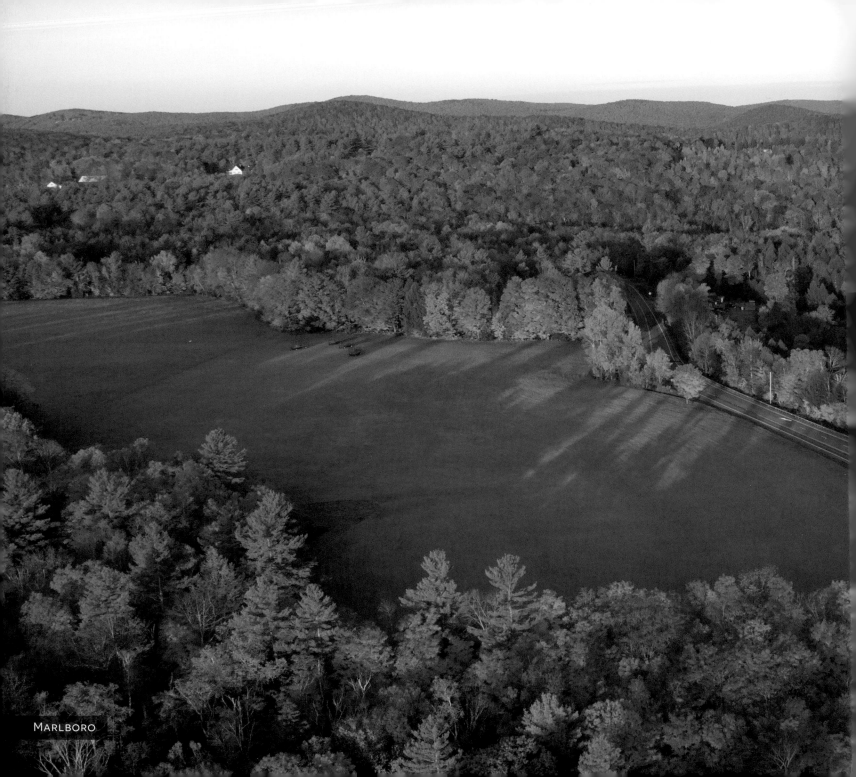

MARLBORO

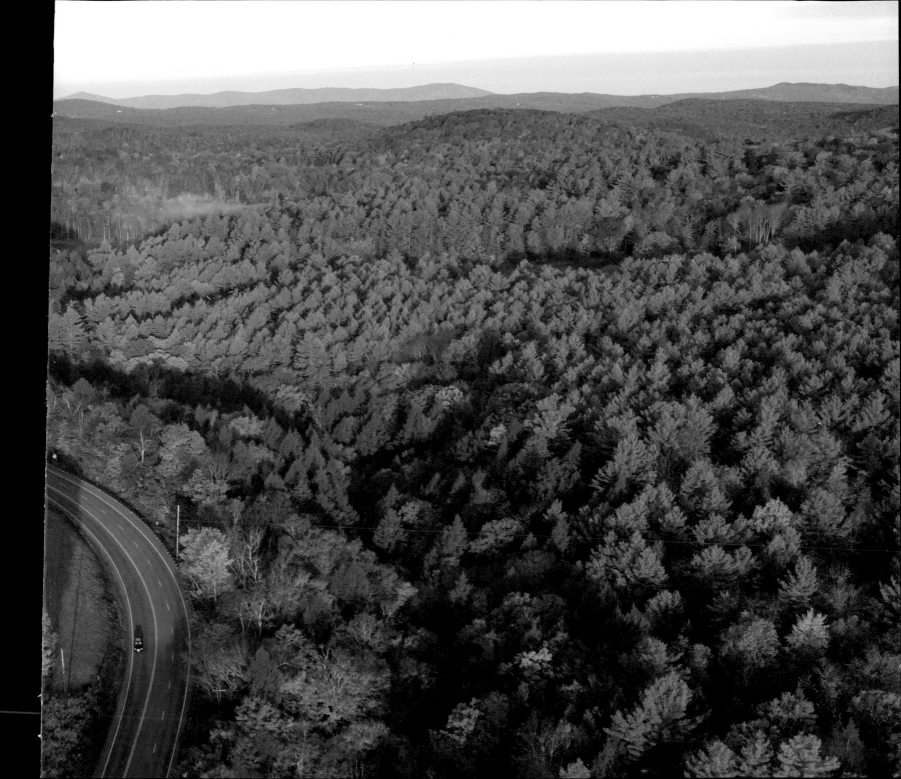

ABOUT THE AUTHOR

Caleb Kenna is a freelance photographer and certified drone pilot. He has more than 20 years of experience as a photographer and writer, and his photographs have been published by the *New York Times, Boston Globe, Wall Street Journal, Los Angeles Times*, Frommer's, *Vermont Life, National Geographic, Yankee, Smithsonian, Sierra, Seven Days, Rutland Magazine, Chronicle of Higher Education*, Lonely Planet, *Education Week*, the Vermont Land Trust, and many other commercial and nonprofit organizations. Caleb loves to create dynamic photographs of people and places. He lives in Middlebury, Vermont, with his wife and son.